IMAGES
of America

THE LANDIS FAMILY
A PENNSYLVANIA GERMAN
FAMILY ALBUM

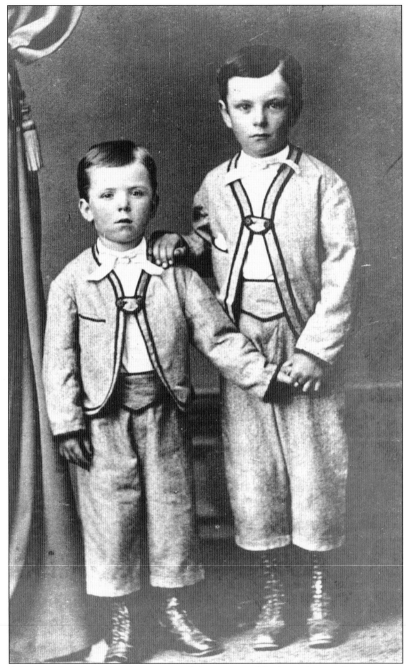

Henry and George Landis were about six and four years old when this studio picture was taken, around 1873. Memories of the Civil War were still vivid and the boys' Zouave-styled outfits recall the popularity of exotically clad soldiers during that conflict.

On the cover: Men sneaking away to play some cards, probably on a Sunday afternoon, were photographed by a grown-up Henry K. Landis about 1900. Please see page 48. (Courtesy of the Landis Valley Museum.)

IMAGES
of America

THE LANDIS FAMILY
A PENNSYLVANIA GERMAN
FAMILY ALBUM

Irwin Richman

ARCADIA
PUBLISHING

Published by Arcadia Publishing
Charleston SC, Chicago IL, Portsmouth NH, San Francisco CA

Printed in the United States of America

Library of Congress Catalog Card Number: 2007943016

For all general information contact Arcadia Publishing at:
Telephone 843-853-2070
Fax 843-853-0044
E-mail sales@arcadiapublishing.com
For customer service and orders:
Toll-Free 1-888-313-2665

Visit us on the Internet at www.arcadiapublishing.com

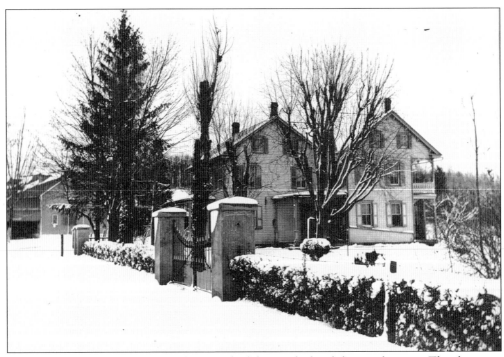

Henry Kinzer Landis (1865–1955) photographed the Landis family house after a rare Thanksgiving Day snowstorm in 1928. The iron gates hanging from the masonry gate posts help demonstrate that the family had pretensions that went beyond farming.

CONTENTS

ACKNOWLEDGMENTS

The Landis Family: A Pennsylvania German Family Album was compiled and written for the benefit of the Landis Valley Associates, a not-for-profit group that helps to support the Landis Valley Museum in Manheim Township, Lancaster County, Pennsylvania. My history with the Landis Valley Museum is a long one, beginning as a young historian on my first visit to the site in 1962. As a staff member of the Pennsylvania Historical and Museum Commission, which has operated the site since 1953, I often participated in programs. As a professor at the Pennsylvania State University (Penn State), I brought many classes to the museum to benefit from its unparalleled collections. Since my retirement from Penn State in 2004, I have become director of research and development for the museum's Heirloom Seed Project. While doing research for the book *Pennsylvania German Farms, Gardens, and Seeds: Landis Valley in Four Centuries* (2007), I became aware of the rich photographic collections in the museum's archives. This would become the genesis of this project. The help of many people was essential to my progress. Key is the continuing co-operation of museum director Stephen S. Miller, who I am also proud to claim as a past graduate student. Bruce Bomberger, Donna Horst, and Nicole Wagner, the professional guardians of the photographic collection, have been ever helpful, as have a cadre of museum volunteers, especially Bob Siever. Most important of all has been Michael Emery, Landis Valley educator and volunteer coordinator, who has a wide-ranging interest in Pennsylvania German culture and who has been my interface with museum collections and technology. Craig Benner has helped to electronically enhance images. Thank you also to Marilyn Monath, Tim Essig, Will Morrow, Joyce Perkinson, Cindy Reedy, Joe Schott, and Trish Frey. I would also like to thank the staff of the library at Penn State in Harrisburg for helping me with reference questions.

In this complex world my books would be impossible without the support and technical expertise of my wife, Dr. M. Susan Richman, a retired mathematician and college dean, who has typed and edited the manuscript. I dedicate this book to her and our family, our sons and daughters-in-law Dr. Alexander E. Richman, Elana R. Richman, Dr. Joshua S. Richman, and Kristin G. Richman and our grandchildren Benjamin David and Zoë Elizabeth Anne. We also have an honorary addition to our family—a third son—Oscar D. Beisert Jr., my last graduate student, who shares my passion for vintage photographs and who has helped me in the selection process and has provided input in the analysis of a number of these photographs.

The "Cottage"
Bainbridge, Pennsylvania
2008

INTRODUCTION

Members of the Landis family of Landis Valley were ordinary and extraordinary. They were typical and atypical Pennsylvania Germans (Pennsylvania Dutch) of their era and the family was always interesting in its contradictions. The principal players were Henry Harrison Landis (1838–1926), his wife, Emma Caroline Diller (1842–1929) and their children Henry Kinzer (1865–1955), George Diller (1867–1954) and Nettie May (1879–1914). A bit player was another daughter, Anna Margaretta, who died in early childhood.

In origin the Landis family is Swiss Mennonite and records show them living about 12 miles south of Zurich as early as 1438. Because of persecution, in 1717 three Landis brothers, John, Jacob, and Felix, and their families fled Switzerland. Two of them, Felix and Jacob, and their families, would establish themselves in Lancaster County and many local Landises are descended from them.

Henry Harrison Landis was son of Henry "Drover Henry" Landis and his third wife, Esther Binkley, of nearby Binkley's Mill. The elder Landis sired 16 children and his namesake was his youngest son, whose reward was to be that he would inherit the family farm. It was a deal that Henry Harrison would regret. Drover Henry had always been a demanding task master and in the last year of his life he was demented and incontinent.

Henry had to cope with his father's problems and his mother's health largely alone. He apparently got very little support from his wife Emma Diller (1842–1920). Their marriage was, from his perspective, hellish and unhappy but it did produce four children. "my wife," Henry wrote, "is a perfect Devil and if she does not change or let up . . . I am going to say good [by] to the whole shop." They remained unhappily married, however, 'til death did they part.

Emma Diller, the daughter of a very prosperous farmer, had attended Linden Hall Academy. Henry H.'s education apparently was in local public school. Their children were to get as fine an education as possible. After starting in local schools, both sons were sent to Lititz Academy as boarding students. Both attended Lehigh University, but only Henry K. would graduate. Nettie May was educated locally and then at prep school in Brooklyn, New York, near where brother Henry K. worked and George often visited.

Central to the story of the Museum would be Henry K. with brother George as his sidekick. Henry K., whose family called him "Lad," would go on to major in engineering at Lehigh University and have a very diverse and cosmopolitan career.

After a few years as a mining engineer and an educator in the West, Henry K. settled in New York City, working as an editor of technical journals, especially those involved with the natural gas industry. For relaxation, he owned a houseboat, which he kept near Port Washington on

Long Island, and he also had a sailboat. Henry K., however, often vacationed back at the farm and visited on weekends.

Like many of their generation of collectors, the Landis brothers packed their buildings with implements of farming and the domestic artifacts of the culture that revolved around farming. These masses of objects were unlabeled. The brothers believed that the best experience for visitors was to have the collections shown by a knowledgeable guide—and who better than Henry K.? The museum's reputation grew, especially among the Pennsylvania German community, but money problems remained a constant concern for the aging brothers. A white knight came to their rescue in the person of a wealthy German-born Reading industrialist. President of Berkshire Knitting Mills, Gustav Oberlaender (1867–1936), founded and headed the Oberlaender Trust for Better Understanding Between Citizens of the United States and Germany. He was also trustee of the Carl Schurz Memorial Association and the subsequent foundation that was created to honor Carl Schurz (1829–1906) who had become a poster boy for American-German relations.

The trustees of the Schurz Association, learning about the brothers' collection, saw it as a vehicle to introduce Pennsylvania German culture to a larger and, perhaps, a national audience at a time when the German image in America needed all the polishing it could get. Eventually a deal was negotiated which would benefit both the collection and the brothers. The Oberlaender Trust agreed to pay for new exhibition buildings. In 1940 the Oberlaender Trust incorporated the Landis Valley Museum. For their part the brothers donated about three acres of land, the original exhibition buildings, and part of their collection. In return the Landis brothers were to serve on the nine-member board of the museum and act as the museum's curators. For the first time a professional assistant was available: Dr. Felix Reichmann (born 1899), a young Viennese emigrant who came to America in 1939 and was employed by the Carl Schurz Foundation as a librarian.

When the newly renamed Landis Valley Museum opened in 1941, trust money had wrought a miracle. There was a new complex of stone buildings: a tavern, the gun shop, and two large sheds for displaying agricultural implements. Behind the scenes there was money for curatorial salaries and general operating expenses.

Money again became a problem as the Oberlaender Trust, heavily invested in German securities, began to run out of money. Almost as important was the fact that no one at the trust, or the brothers themselves, had the professional experience to develop the site further. No one had the stamina and determination to catalog the collections or to consistently interpret them. The trust and the brothers turned to the state government for help and, after years of negotiation, the Commonwealth of Pennsylvania took title to the land, buildings, and collections of the museum as well as additional land, buildings, and additional collections owned by the Landis brothers. The brothers, George, then 85, and Henry K., 87, retained life tenancy of their family home, kept some of their collections, and received lifetime appointments as curators. The museum would be administered by the Pennsylvania Historical and Museum Commission (PHMC), which in co-operation with the Landis Valley Associates still operates the facility.

The PHMC enlarged the purpose of the museum by renaming it the Pennsylvania Farm Museum at Landis Valley, acquiring more land (including some the brothers had sold), moving in historic buildings, and creating new-old buildings to enhance the vision of crossroads village life. A new farm with buildings constructed of logs was created to demonstrate farm life in the 18th century. The Jacob Landis farmstead and the Landis Brothers farm would concentrate on 19th century farm life. Gardens were recreated, or newly created along historic principles. Historic farm animals were introduced and the enormous Landis Valley collection, amassed by the founders and added to by many donors, is finally being cataloged and housed in new, appropriate, storage and exhibition buildings. An Heirloom Seed Project was founded in 1985 to provide historically correct seeds to museums and the general population. Today, farming and gardening are again central the Landis lands, where agriculture had never entirely ceased. Today you can see the Landis collection in buildings, enjoy the fruits of historical research in period gardens and fields reflective of the 18th and 19th centuries.

It is a vision preserved.

One

FARM DAYS

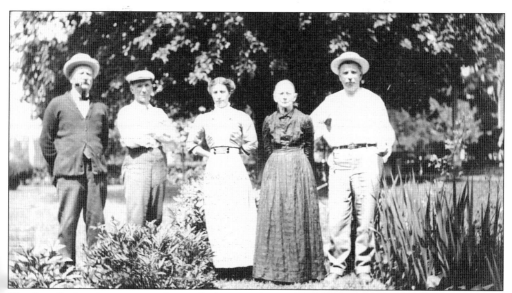

The Landis family poses on their side lawn early in the 20th century. They are, from left to right, Henry Harrison (father), George Diller, Nettie May, Emma Caroline (mother) and Henry Kinzer. George, who chose to remain in Lancaster County, looks like a farmer. Henry K., who was working in New York City, has the relaxed appearance of an urbanite on vacation.

George and Anna Diller were the parents of Emma Caroline Diller, who would marry Henry H. Landis. Church people, they owned a prosperous nearby farm and were very fond of their grandchildren, Henry K., George, and Nettie May. They are posed on their front porch on a summer day. The shutters on the parlor windows are closed to keep out summer sun. Note all of the houseplants enjoying the summer outdoors.

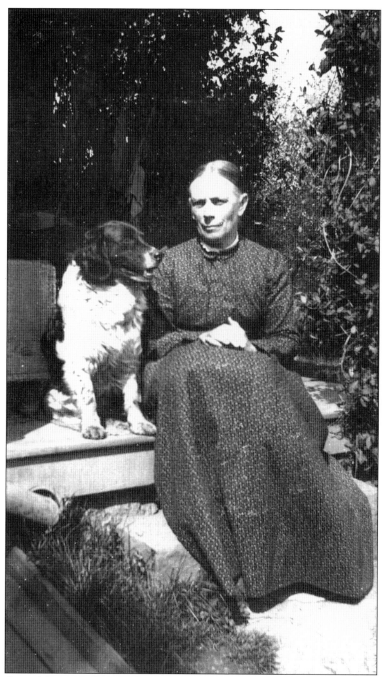

Emma Caroline (1842–1929) was the well-educated daughter of an affluent Pennsylvania German farm family. She had attended Linden Hall Academy in nearby Lititz, a school founded by the Moravians in the 18th century to educate girls. It was one of the first such schools in America. Maintaining control over her dowry, she also inherited substantial money from her parents. Money questions led to many arguments with her husband, Henry H. Landis, who had a more casual attitude towards money than did she. Along with the rest of her family Emma loved animals. Pets are seen in many photographs of her.

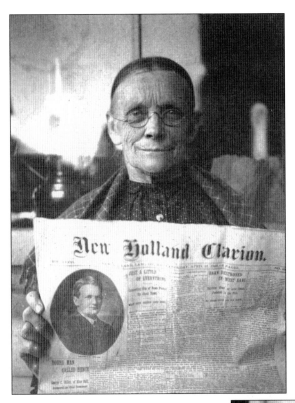

Emma Caroline Landis enjoyed reading the paper and she was very fond of her daughter, Nettie May, who was born when she was 37 years old. A younger daughter, Anna Margaretta, died in early childhood. Emma was a very careful and frugal housewife who oversaw the building and decoration of the new family farmhouse in the 1870s. She apparently lost her teeth early in life and, accordingly, smiles are rare. Broad smiles are non-existent. The *New Holland Clarion* she is reading is dated April 11, 1900. She and Nettie May pose in a downstairs window of their farmhouse.

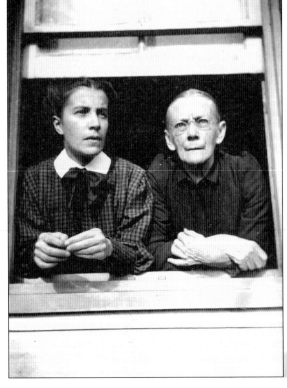

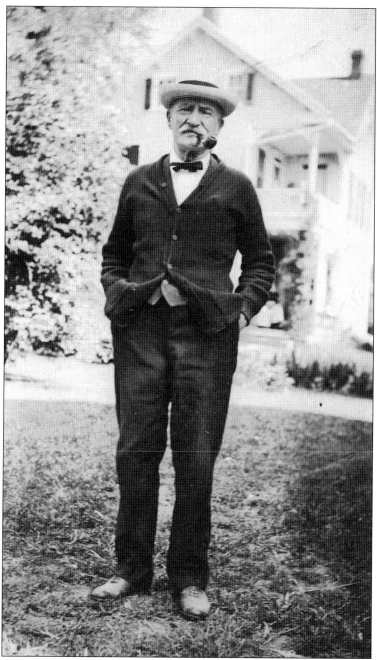

Henry H. Landis (1838–1926) looks every bit the country gentleman. He was a reluctant, if successful, farmer. As the youngest son of a prosperous farmer (also named Henry), who had sired 16 children by his three wives, Henry H. assumed the responsibility for his elderly parents with the promise that he would inherit the homestead farm. It was a deal Henry would regret. On March 13, 1876, he wrote in his diary, "I done so an awful Business I got into by coming into this house if I had to do the thing again I would never come here if I was paid $3000 a year." Only after his father's death, did Henry H. learn that he had been left only a lifetime interest in the farm, with ownership passing to his sons, George and Henry K.

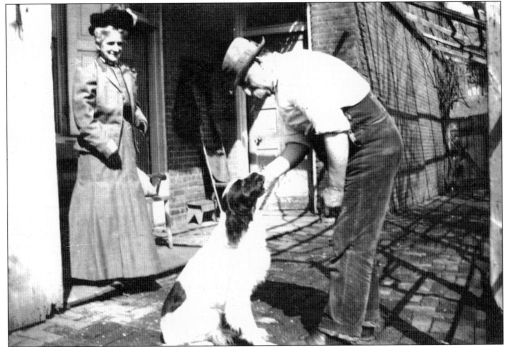

Like everyone else in the family, Henry H. Landis was fond of animals, especially dogs, and in his diary are many entries describing getting butcher scraps for dog food. A fashionably dressed woman, probably a relative, watches as Henry pets a dog while on visit to a nearby house. There were always Landises around. In the lower picture Henry, with his back to the camera, chats with two men identified on the photograph as B. B. Landis (center) and J. S. Landis.

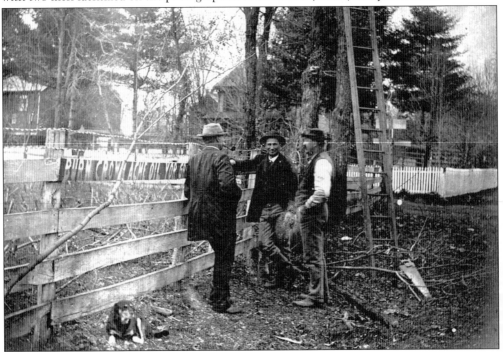

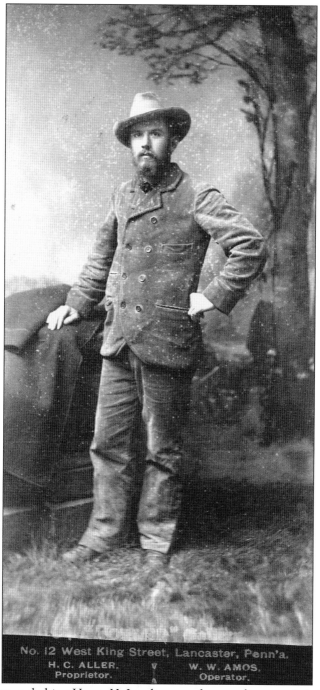

No. 12 West King Street, Lancaster, Penn'a.
H. C. ALLER, W. W. AMOS,
Proprietor. Operator.

Before his marriage, a dashing Henry H. Landis poses for a studio portrait in Lancaster at the studio of H. C. Aller. Always adventurous and restless, his marriage to Emma was unhappy. This was caused, in part, by his overwhelming desire to strike it rich, coupled with a poor business sense. In addition to farming, he ran a limekiln, sold chemical fertilizer, and speculated in tobacco, all with mixed results. While his education ended with a local primary school, he, like Emma, wanted their children to receive good educations.

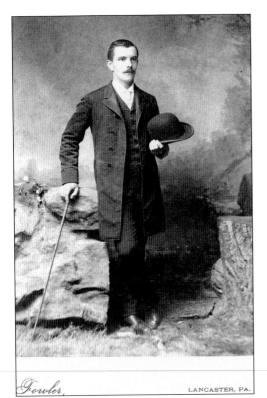

Henry K. Landis (left) and his younger brother, George Diller Landis, were in their early 20s when they posed, around 1887, for Lancaster city photographer Lewis C. Fowler. Henry, looking debonair, was always to be the more dapper and formal brother. Both were very active physically and proud of their trim muscular bodies. From the early 1880s through the early 1900s they had themselves photographed nude each year for a series they called their "Anthropometric Studies," which are now, alas, lost. The brothers were anything but simple farm boys.

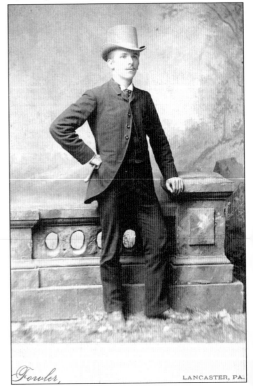

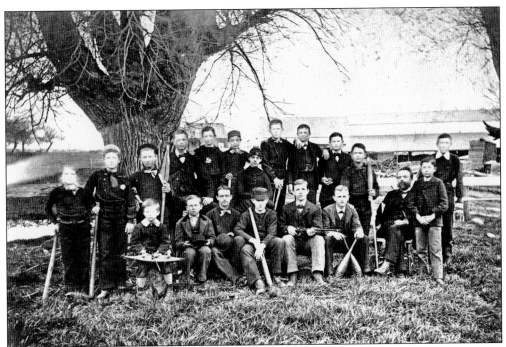

Young Henry, seated and holding a rifle, poses while a student at the Lititz Academy in 1882. The bearded gentleman is the school's principal, "Professor Hepp." All of the props the boys hold flags, guns, and exercise equipment and exude masculinity.

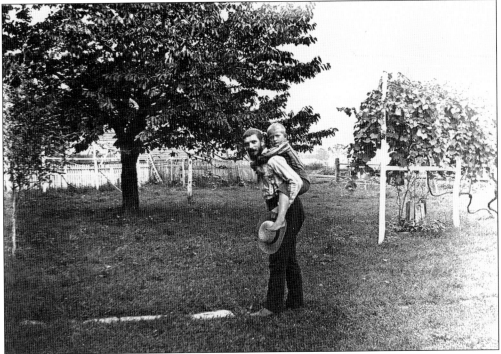

Henry is seen horsing around with his young cousin "Little George" while visiting at his Diller grandparents' farm in the late 1880s. Note the grape arbor in the background at right.

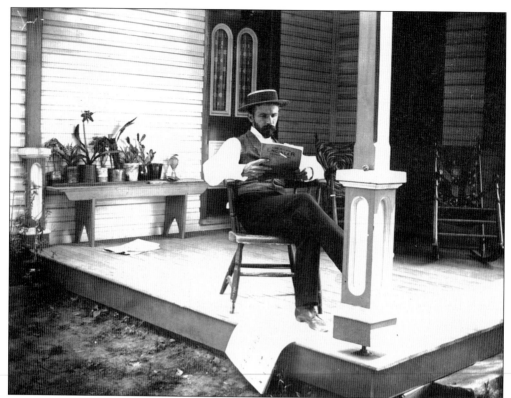

"HKL on Vacation" is the legend in the family album. Henry K. Landis sits on the side porch of the family home. Growing a beard by his freshman year in college, it is hard to know if he was home from college or from his career. Note the houseplants on the bench, summering out of doors, as well as Henry's formal attire.

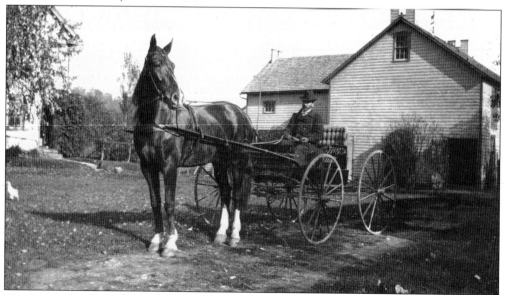

The Landis family prided itself on its fine carriage horses. Henry poses proudly in a rig on the family farm, around 1890. The horse was probably Billy, their favorite driving horse.

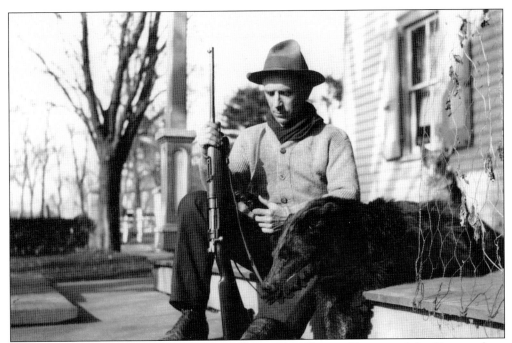

George Diller Landis was an avid hunter and a member of several hunting clubs. He poses here on the side porch with a bear he shot, apparently nearby.

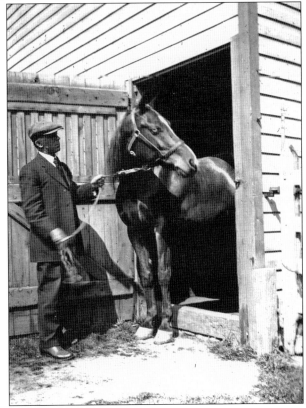

George is seen here bringing the Landis' driving horse Billy out from the stable, which would later become a museum exhibition building.

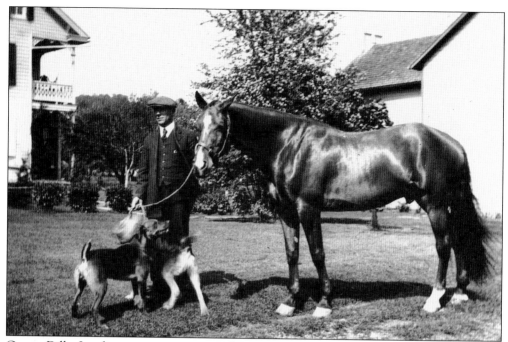

George Diller Landis as a country squire is shown posing with horse Billy and two of his hunting dogs. He holds a feed bucket in his hand. A corner of the Landis house is seen to the left.

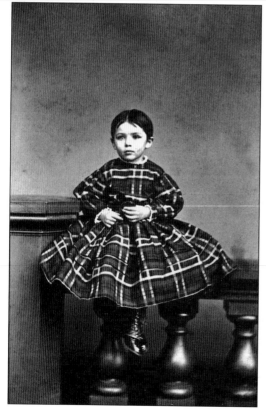

Little Anna Margaretta Landis died shortly after this *carte de visite* photograph was taken. A younger sister of George and Henry K. Landis, this is her only known image and has only recently been found.

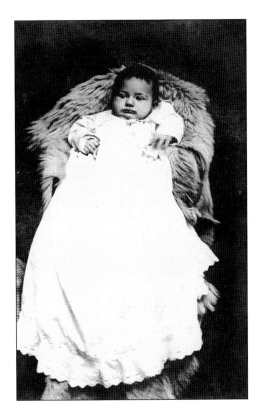

Nettie May Landis (1879–1914) was the last child born to the Landis family and was absolutely adored by both her parents and her much-older brothers. In contrast to her shorter-lived sister Anna Margaretta, she was very much photographed, both professionally and by her eldest brother Henry. The studio portrait at right shows her in her christening gown posed on a bearskin rug, a photographer's prop that was popular at the time. In the portrait below, she is about age 10. Her mother always kept her hair short, which was hygienic, although certainly not fashionable. Note her jeweled necklace.

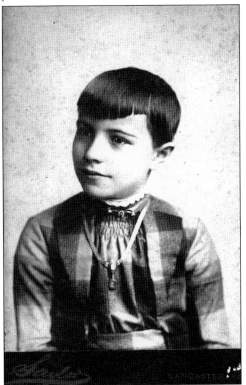

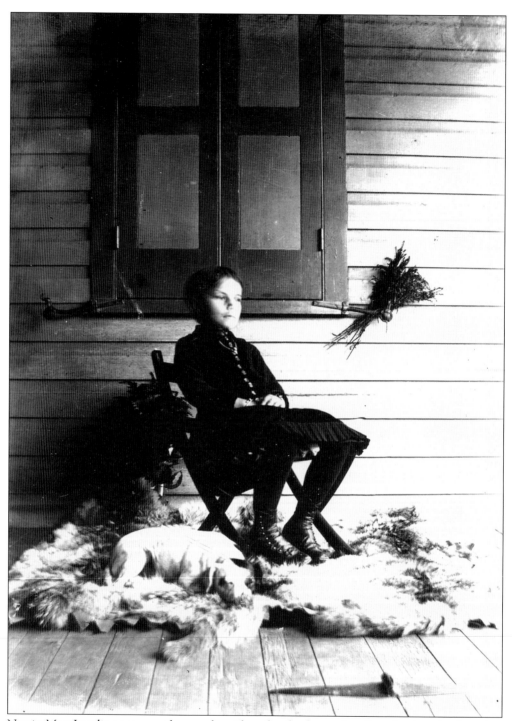

Nettie May Landis poses on the porch with a family dog at her feet sharing the bearskin rug, which may have been used in her baby picture. Note the fly chaser tucked into the shutter hinge.

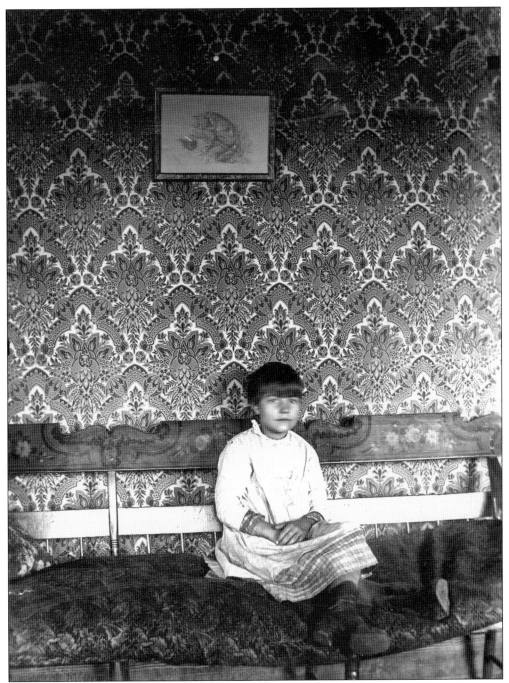

The sitting room of the Landis home was a mixture of the old and the new. The wallpaper is influenced by the designs of William Morris (1834–1896), the important British tastemaker. The settle Nettie May sits on was locally made and derived from traditional forms. It can be seen, today, in the Landis House.

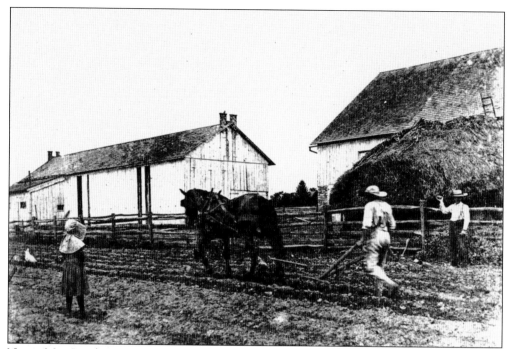

Nettie May Landis was a farm girl. Above she watches as a hired man does the fall plowing at Landis Valley. Note the huge haystack, complete with a ladder. In front of her is a now-demolished tobacco shed, built in the 1870s. Opportunistic chickens scratch for grubs and insects in the newly turned soil. Below, still wearing a bonnet to protect her face from sunlight, a barefoot Nettie May poses with her pet dog on a log.

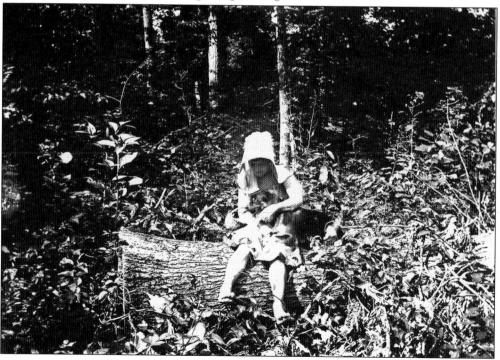

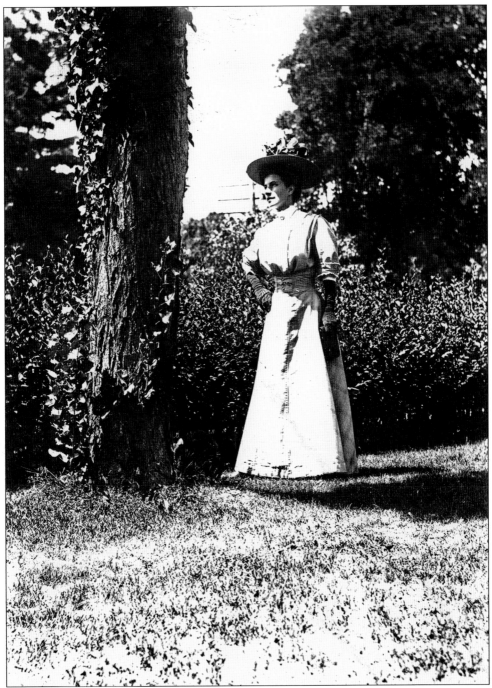

While she grew up on a farm and did her share of chores as a girl, Nettie May clearly had been brought up to be an upper-middle class lady rather than a farmer's wife. Encouraged by her family, her education was fitting. As a fashionable young woman, she studied dancing and painted porcelain, as well as oil paintings that decorated her family home. As a stylish young woman, she poses on the family lawn photographed, as usual, by her doting eldest brother, Henry K. Landis.

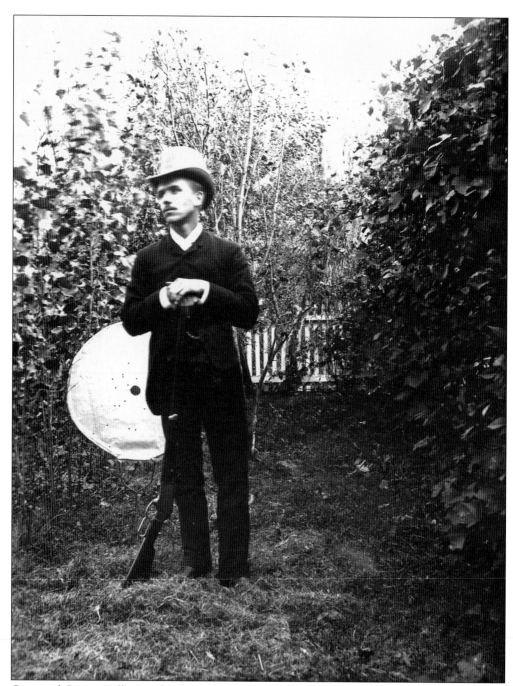

Guns and George Diller Landis always went together. He was a target shooter, as well as an avid hunter. Seen here, a target behind him, he is formally attired as a gentleman-shooter. Never as avid a collector as Henry K., he nevertheless contributed to the future Landis Valley Museum by amassing not only a gun collection but many implements devoted to both hunting and fishing; these included fish spears and nets and animal traps.

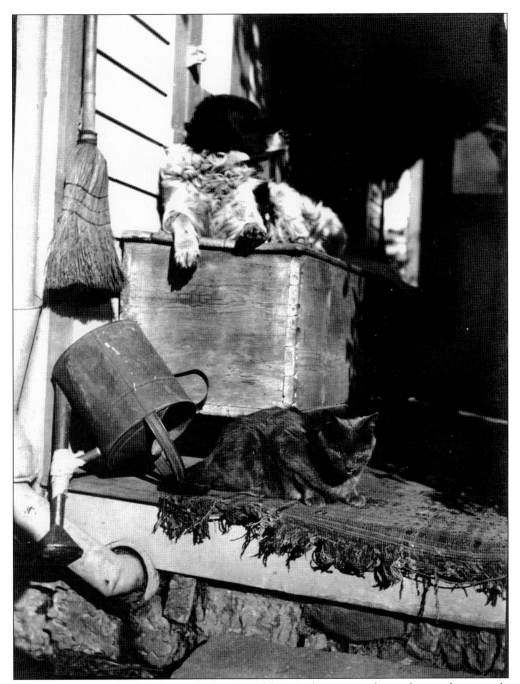

Pets were all over the Landis family house and barn. There were always dogs and seemingly countless cats. George especially was fond of felines and would have over 20 pets at one time. His neighbors considered the elderly bachelor to be rather peculiar. Photographed by Henry K. Landis about 1890 is a homey back-porch scene in which a large scruffy dog, perhaps one of a series named "Waser," lies on the wood box while a cat perches on a rag rug next to Emma Landis's patched watering can.

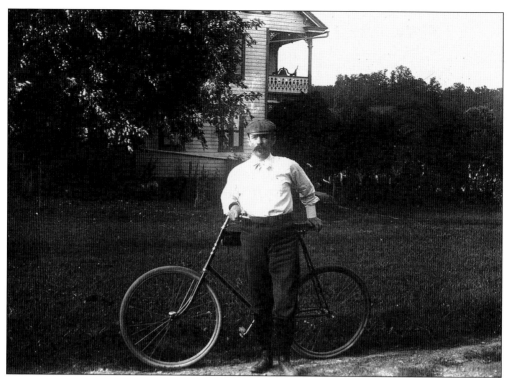

Henry K. and Nettie May Landis were avid bicyclists. Both are shown with their "machines" at the family farm early in the 20th century. Henry is obviously home on vacation. Nettie May's bicycling costume, influenced by the early feminist bloomer costume advocated by reformer Amelia Bloomer (1818–1894), was considered very stylish and advanced for its day.

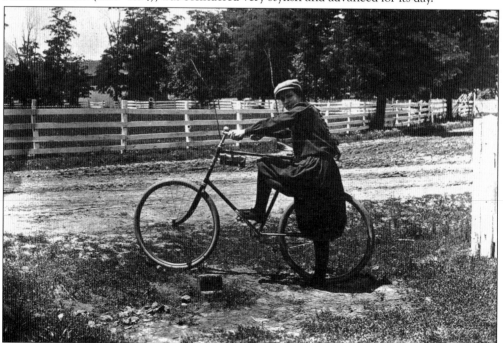

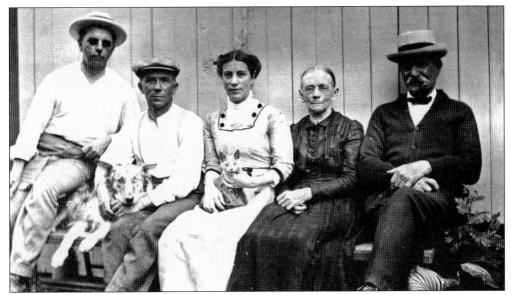

Early in the 20th century, the Landis family posed for their portrait on a summer day. Above, they are, from left to right, Henry K., George Diller, Nettie May, Emma, and Henry H. This is a rare adult picture of a clean-shaven Henry K. None of the three Landis children ever married, and they were often together. As always, animals appear as regular family members. In the photograph above, Henry K. is wearing sunglasses. Down below, George's dog is wearing them. Note that Henry holds a cable to trip the shutter of the camera used to take these photographs.

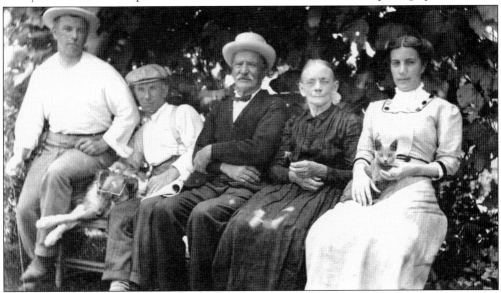

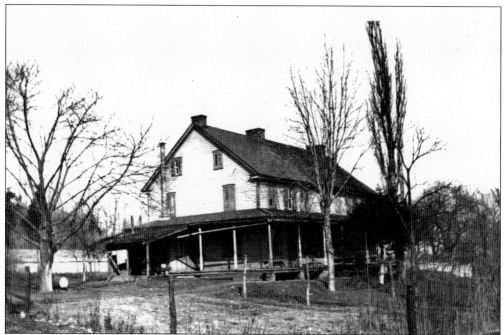

Grandfather Henry Landis's house, built of stone, is the original family farmhouse. The family rented it out after they built their new modern frame house in the crossroads village of Landis Valley. The brothers sold it after their parents' death, no doubt to raise money for their museum. Nettie May Landis and a dog pose near the house, which stands today as the center of a farmette and, alas, it has been swallowed up by suburban sprawl.

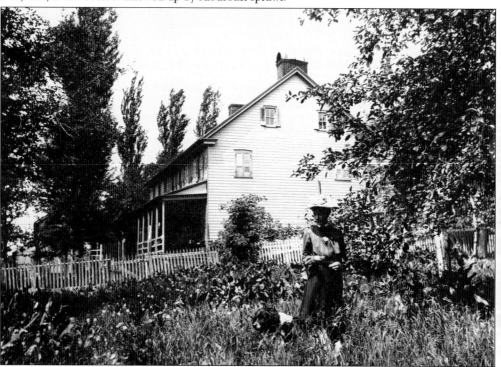

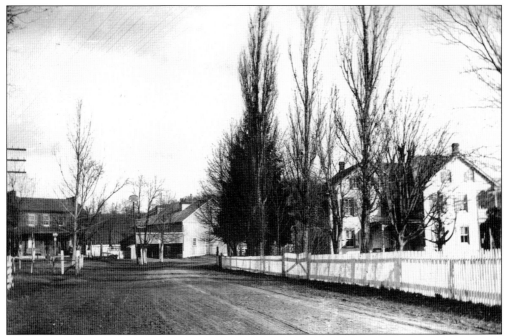

The crossroads village of Landis Valley is seen in a c. 1900 view. Note the dirt road. In the left background is the still-standing Landis Valley Hotel, built in 1855–1856 for Jacob Landis Jr. Next to it is the Victorian-era livestock auction barn. No longer standing, it has been replicated as the Landis Valley Museum's transportation building. The Landis farmstead is on the right.

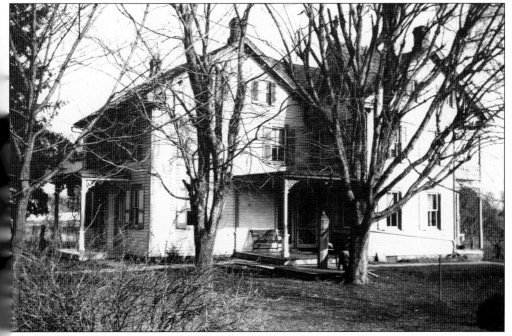

The Landis house was built in sections. The front, featuring fashionable Italianate and Gothic Revival details, was built in the 1870s. Inside the two–front door house is the traditional three-room German floor plan. The rear portion was added in the 1880s.

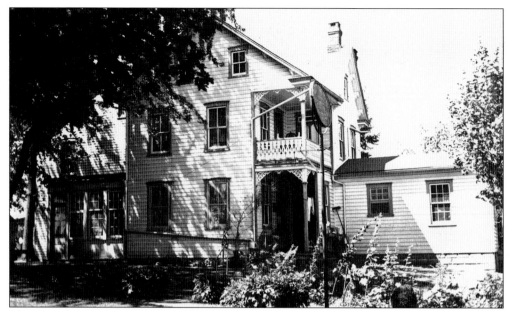

The "Landis Residence," as Henry K. Landis called it, reached its full size in 1920 with the addition of a new kitchen wing.

Henry H. and Nettie May Landis are pictured near their home in the early 20th century. The smoke house and butcher house, seen behind Henry, no longer exist. Note Nettie May's elaborate hairdo.

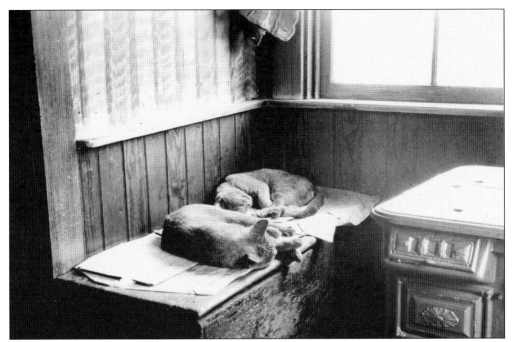

Cats sleep contentedly on a newspaper-covered wood box next to the kitchen range (a wood and coal-fired stove) in the Landis family kitchen, around 1900.

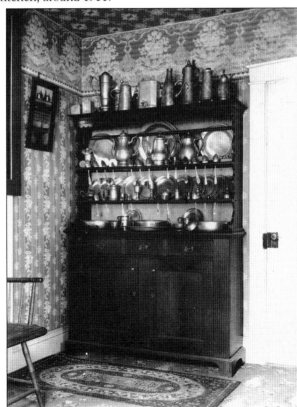

This interior view of a pewter-filled Dutch cupboard was, no doubt, taken about 1900, and it demonstrates that collections were appearing in the Landis home. In later years after the parents' deaths, the rooms almost lost all traces of their original functions, filled as they were with the Landis brothers' collections.

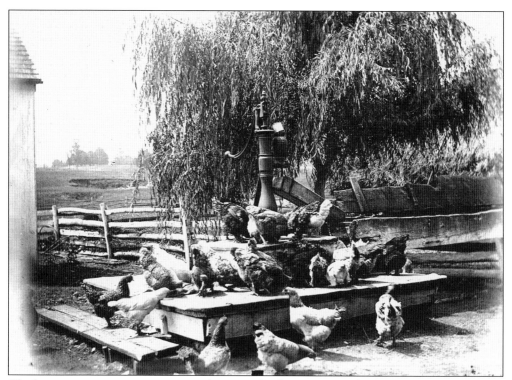

Chickens were an important source of income for farm wives in the late 19th and early 20th centuries. Eggs especially were a ready cash crop, or they could be traded for goods at the local country store. Chickens often congregated for a drink near the pump in the farm yard. The chicken house on the left no longer exists. When automobiles became commonplace in the post–World War I days, Henry H. Landis started to lock his chicken house at night because of a distrust of strangers in the neighborhood.

A proud rooster was photographed against Landis Valley's large-for-the-period chicken house. Emma Landis was proud of her flock and is seen feeding the birds, a chore she often shared with the "hired girls" who worked for her. Whenever the lawn was mowed, the grass was carefully raked, and the clippings were often claimed by Emma for "her chicks."

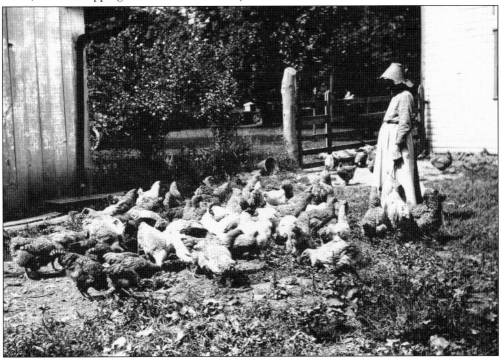

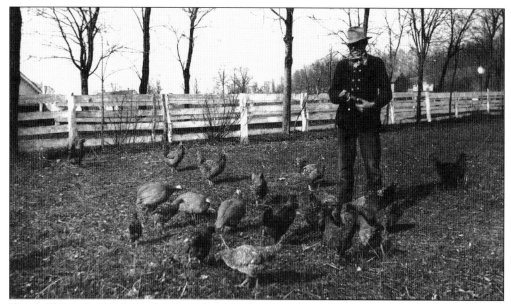

Henry H. Landis is seen looking at what his photographer son, Henry K., described as "Spring Chickens and Guineas." Spring chickens, plump and ready for market early in the season, brought a premium price. Guinea fowl were prized for their tender meat. They were also allowed in gardens where they would eat insects without scratching in the earth as did chickens.

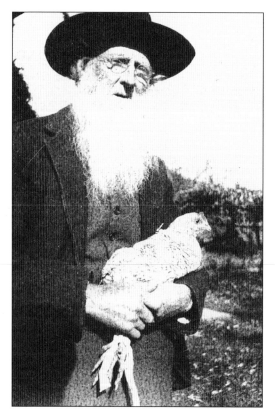

Aaron Whitcraft "With a Chicken to Sell" was a poor local farmer, who often worked as a laborer for the Landis family, as did other members of his family.

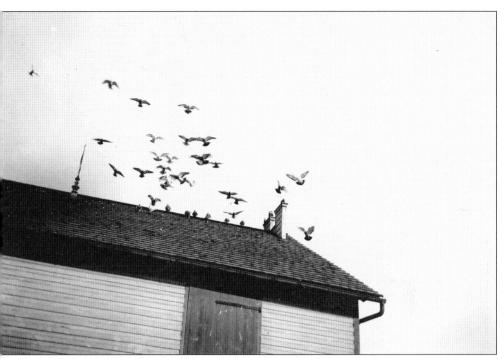

Pigeons, which were raised for food, have almost disappeared from modern American farms. If found today, the birds are raised by specialists as a high-end delicacy. Tender young pigeons, or squabs, are especially succulent. The Landis family kept pigeons, which were housed in a farm building attic—probably that of the chicken house.

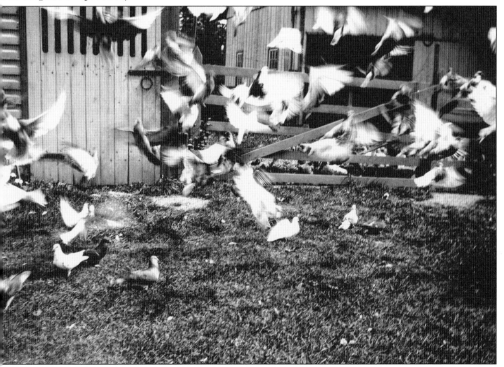

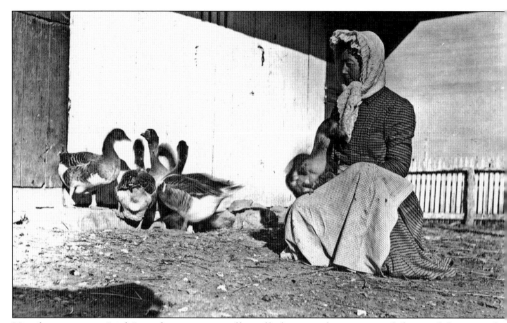

Hired women, or "girls" as they were usually called, were always part of the workforce at the Landis farm during Henry H. and Emma Landis' lifetimes. One hired girl is shown with a flock of geese. Geese were favored for holiday eating and for their large rich eggs. Below a "Farmer's Wife" helps out with gardening chores.

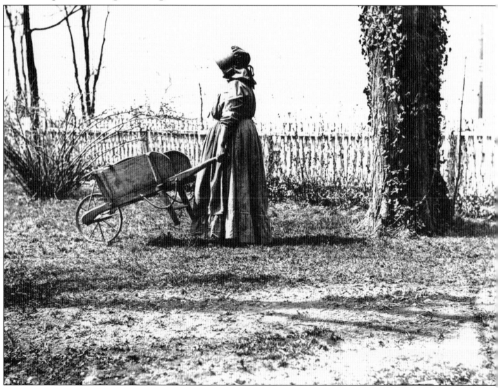

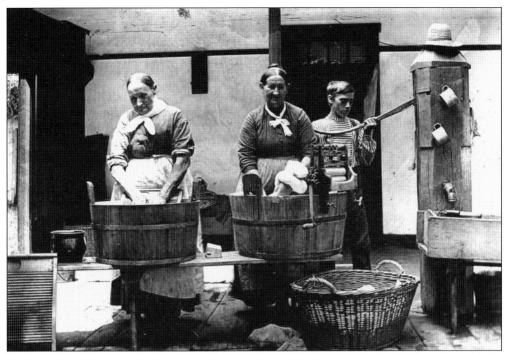

Washday, always a Monday (but not every week), was arduous for family and the hired help. Henry K. Landis photographed this *weschhaus* (washhouse) scene at George Diller's (the brother of his mother, Emma) farm near New Holland in the 1880s.

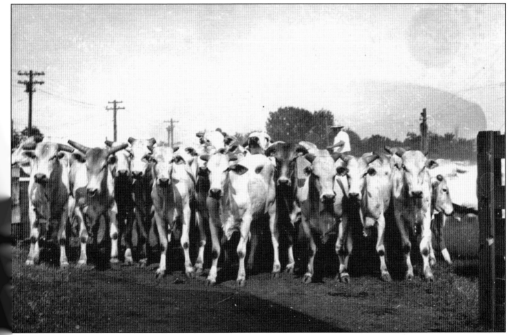

Cattle were a common farm sight during the Landis family's lifetime. Henry H. often boarded cattle, for a fee, for the operator of the livestock auction at the village of Landis Valley. Henry K. photographed this herd at the nearby Lancaster Stockyards.

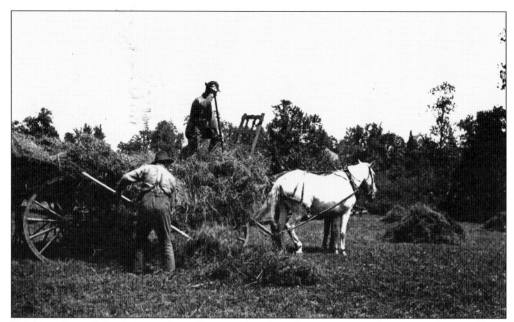

"Making hay while the sun shines" was a familiar chore on every Lancaster County farm. Henry K. Landis photographed these hired men at work loading hay around 1900. Note the hand-raked piles waiting to be loaded and transferred to storage either near or in the barn.

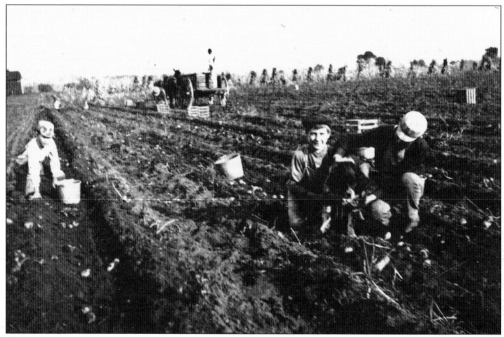

Harvesting potatoes was very labor-intensive, but the tubers were a significant crop at Landis Valley where they were used as animal feed as well as sold for human food. After the above-ground plants matured, a special plow dug up the potatoes, which then had to be picked by hand. Henry H. Landis proudly used "Paris Green" (an arsenic compound), a new discovery, to protect his crops from insects.

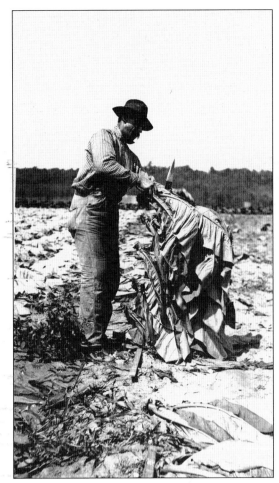

Tobacco was Henry H.'s favorite crop because it was so profitable. Farmers extolled it as the "Mortgage Burner." It was, however, the most labor intensive crop grown at Landis Valley. After all the plants were cut, by hand, they were speared onto laths and placed on special wagons that transported them to the tobacco barn where the crop air-dried. All of the Landis children, as well as Henry H. and Emma Landis, had their own tobacco patches and kept the money their plots produced. Henry H. complained in his diary that he often had to do the work on "Lad's" (Henry K.'s nickname) patch and always on Nettie May's. The kids, however, were always there for the money. In addition to being a grower, Henry K. was also a speculator—making and losing substantial sums of money.

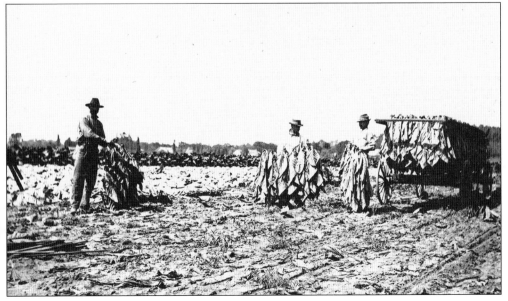

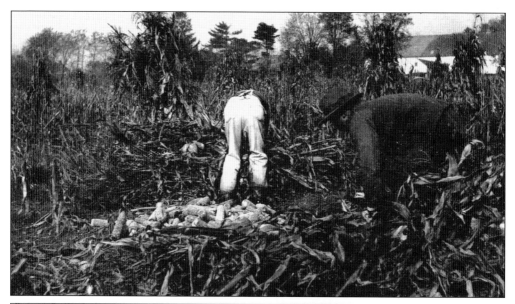

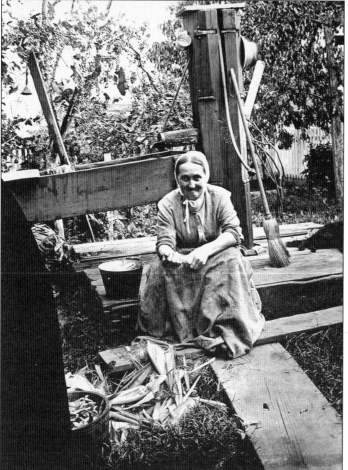

Henry H. Landis's diary has frequent entries detailing the amounts of money he paid farm workers to husk corn before the machine age. The hired men often husked the crop right in the field after removing the ears from the stalks. Women generally had the harvested ears delivered to them and worked near the house. This hired girl was probably husking corn to be used for chicken feed and is at work in the yard of the Landis home.

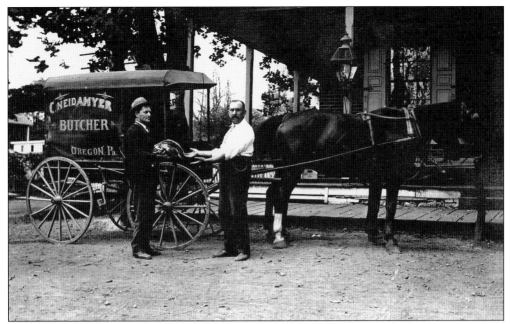

Photographed by Henry K. Landis in 1912, Jacob Duing, who was then the proprietor of the Landis Valley Hotel, built in 1855–1856, receives a meat delivery brought by a butcher from the nearby town of Oregon. Horse-drawn delivery wagons were a familiar sight before the automobile age.

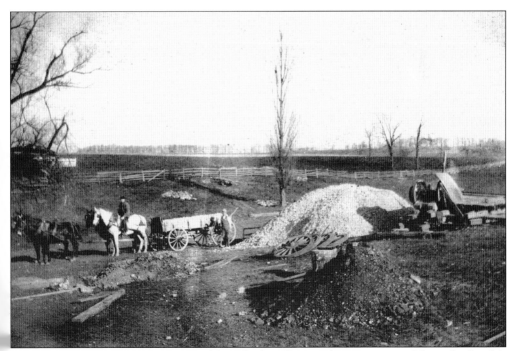

Both Henry H. and his son George sold crushed road stone that was quarried from the family's land. George often contracted with the county to provide crews for road work, as well.

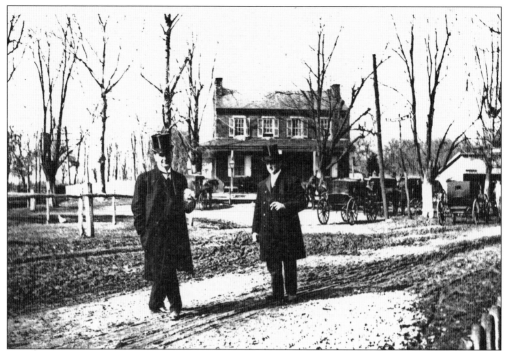

"Landis Valley Swells, about 1910" is one of the most attractive and enigmatic photographs in the family albums. Taken by Henry K. Landis, with the Landis Valley Hotel in the background, the row of carriages suggests a wedding party.

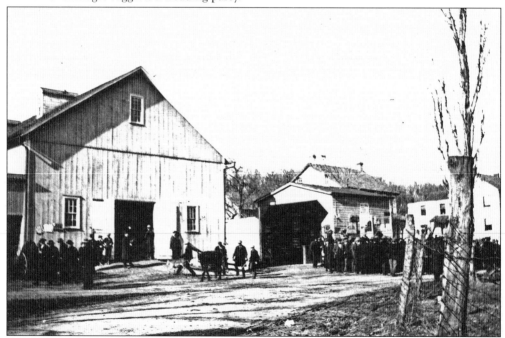

"Sales Stable and Scales at Landis Valley Hotel," the title of this image, shows the large wooden sales building on auction day. The scale seen at the far left was used to weigh cattle before they went on the block.

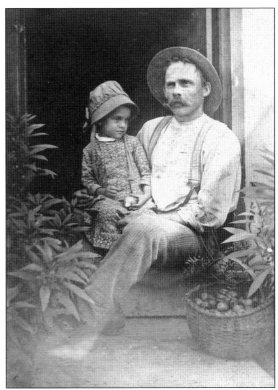

As a photographer, Henry K. had an eye for intimate detail. Among his studies were these photographs of farm folks who worked for the Landis family. A young farmer, Jake Krik, and his daughter, "Berther," rest on the threshold to their house. His split oak basket is filled with small potatoes, probably culls from the harvest, which suggests that the picture was made in early autumn. Below, Barbara Burkhart is seen peeling an apple over a tin-lined tub resting on her lap. She sits against a door in a shed, or possibly a summer kitchen. Note that daylight can be seen between the wall's vertical boards.

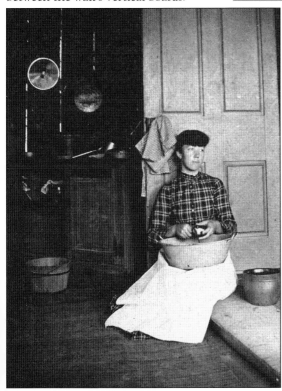

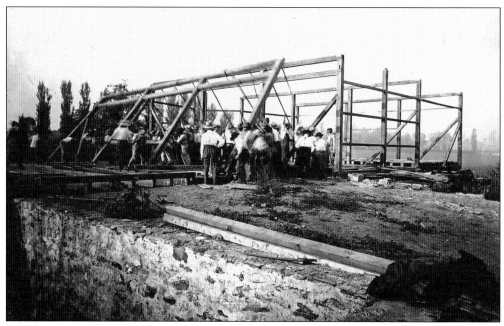

Barn raisings are a quintessential Pennsylvania German event. Unfortunately, today they only survive among the Amish and the Old Order Mennonites. They have been depicted in various media, perhaps most famously in the movie *Witness* (1985), which starred Harrison Ford. Barn raisings were still normative in 1914 when Henry K. Landis photographed this event at the Haydn Bamberger farm "Lititz R.D. 3." Before the raising, professional carpenters would prepare the framing timber; volunteers, under their direction, would do the rest. After the frame was in place, the whole group posed for a picture. The women fed the men. The children carried some supplies and drinks to the workers.

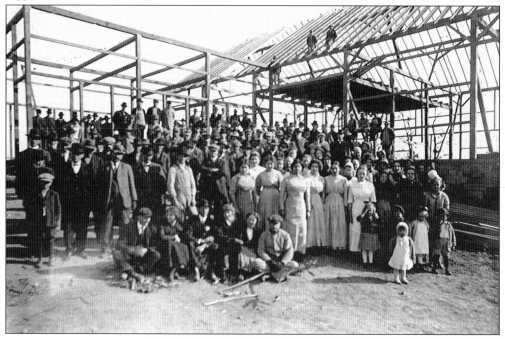

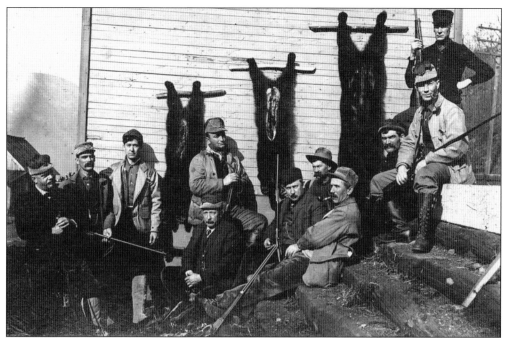

George Diller Landis, the avid hunter, prized his membership in the still-existent West Branch Hunting Club in Whetham in Clinton County, Pennsylvania. Also a social organization, the club sponsored breakfasts at Lancaster's elite Hamilton Club. Trophies of a successful bear hunt are mounted on the wall of the Whetham railroad station on "Nov 15, 1907." George, with a rifle on his lap, sits on the far right. Other successful hunters carry deer back to camp, which was a large, commodious house.

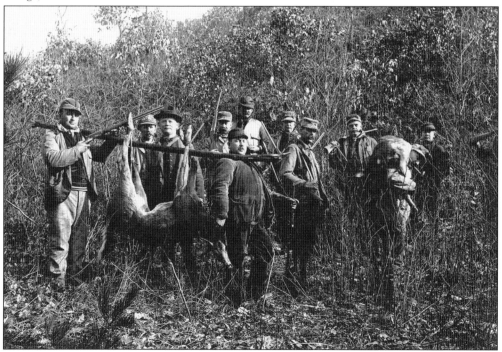

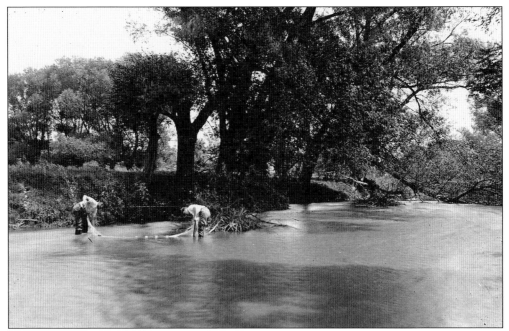

Fishing nets were commonly used on local waterways. This scene was probably photographed along what was then called the Conestoga Creek. On a March day in 1876, Henry H. Landis noted in his diary that a relative had come to dinner and then went to a neighbors "to lift some nets, I believe they had a fishing party."

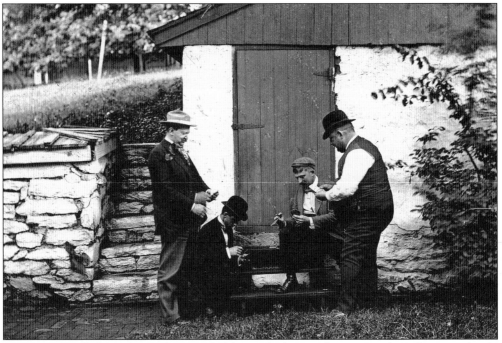

A group of well dressed men have probably sneaked away from a Sunday afternoon family gathering to play cards behind a spring house or by the entrance to a ground cellar, frequently a male hiding place.

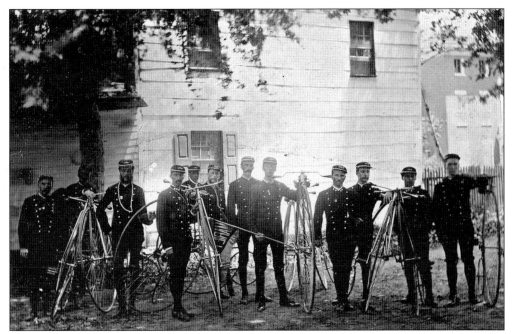

The caption on the back of this photograph reads: "The Marietta PA. BICYCLE CLUB Taken in 1882 they had Uniforms and all had full nickel plated wheels costing from $130. to 150 Dollars Each." No Landis family members are in the group that included local merchants, bankers, and "George Rudisill, Tel. Operator."

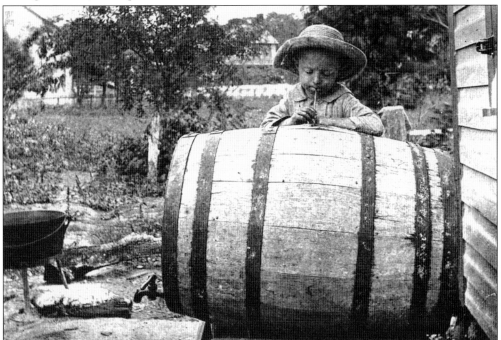

Young Jake Stump uses a straw to siphon a drink from a bung hole in a barrel at Landis Valley. One can hope that it is rainwater, but it was probably either sweeter or more potent. Notice the cast-iron pot on a tripod to the right. It is of a type often used in the brewing process.

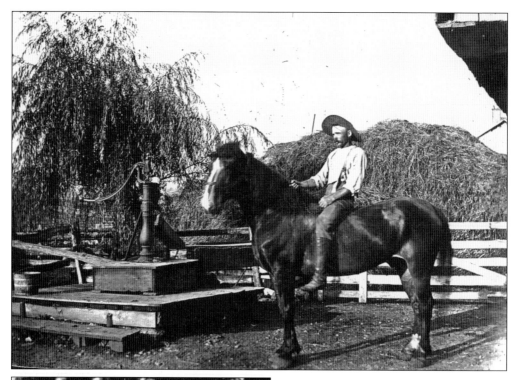

A common theme seen in Henry K. Landis's photographs was men at work. In the picture above, a hired man, probably Jake Krik, poses on a horse near the cast-iron pump in the Landis family's barnyard. Note the forebay of the barn at the upper right and the massive haystack behind the horse and rider. At left is a marvelous character study of a zoo keeper at the no longer existing Lancaster Zoo, posing with one of his primates.

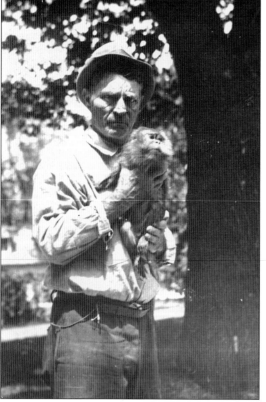

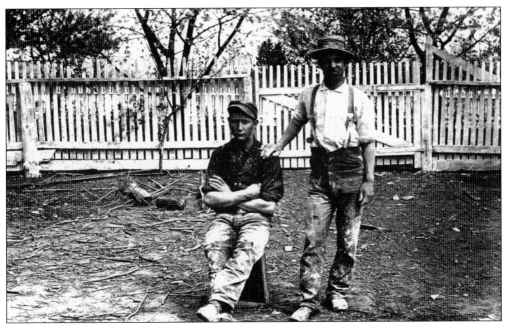

Henry was a close friend of the Witmer family of Lancaster and especially of their son John Witmer Jr., who would later visit him when he lived in New York City and Port Washington, New York. In the 1880s, he photographed the two workmen, probably brothers, on the Witmer property at about the same time he photographed two upper-middle class men by a large tree. John Jr. is to the right.

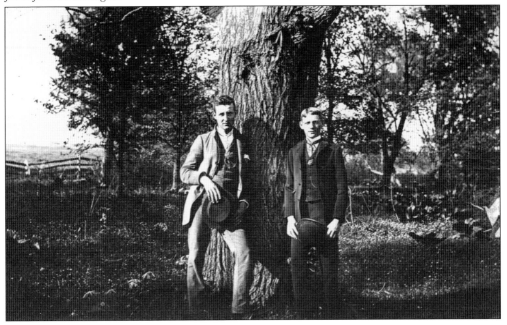

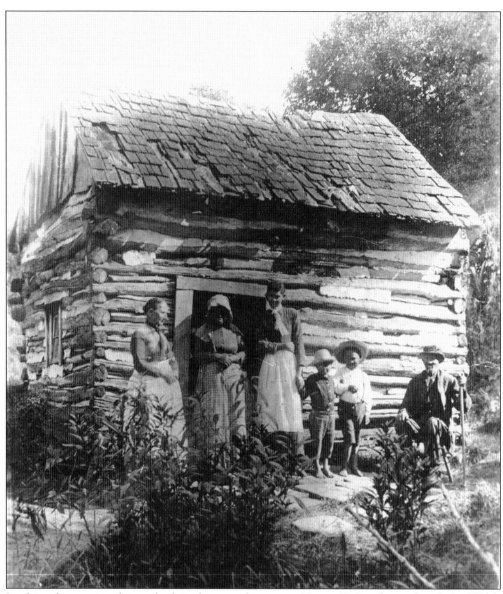

Looking for exotic subjects for his photography, young Henry K. Landis explored the Welsh Mountains, hills that skirt the Lancaster-Chester County border. In the 19th century and well into the 20th century, many considered the Welsh Mountains to be a no-man's land. Poor farmland, most of its residents were hardscrabble folks who eked out a bare existence. The region had a longtime population of free African Americans and was known as a place where the races even mixed. Henry would make many photographs of this unusual population. Here "Old Bobbie Springer" is seen with his family posed in front of their almost derelict log cabin. Springer, ancient at the time, was believed to have driven a wagon during the War of 1812.

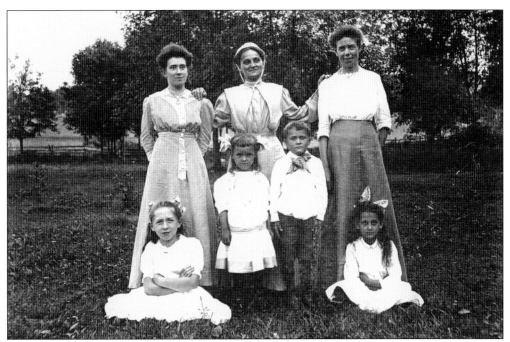

While many of the Landis family photographs are identified, many others remain anonymous but are nevertheless fascinating. The two on this page illustrate the ongoing secularization and modernization among the Pennsylvania Germans. In the picture above, a woman (probably the mother) in the plain dress of a sectarian rests hands on the shoulders of two young women (likely sisters) who are dressed in "English" (non-plain) fashion, as are their children. In the photograph below, a plain-clad couple, probably Mennonites, pose with their five sons—all fashionably attired. Emphasizing even more the shift to the worldly is the presence of a large touring car.

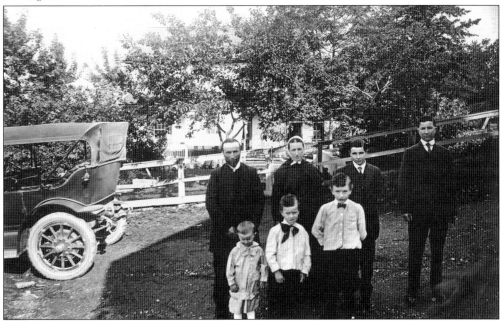

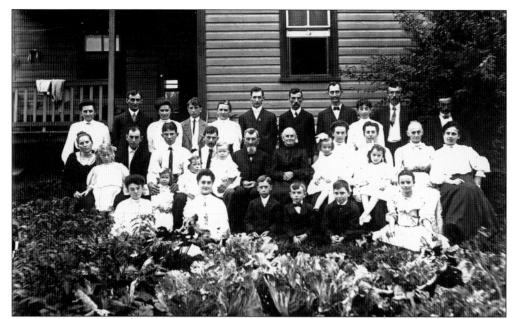

A large and prosperous, but unpretentious, multi-generational clan gathers around the family patriarchs overlooking the vegetable garden. Note that no one thought to take away the work cloths hanging over the rail to the left. Also note the screen in the open window to the right. Screens were a recent innovation at the time.

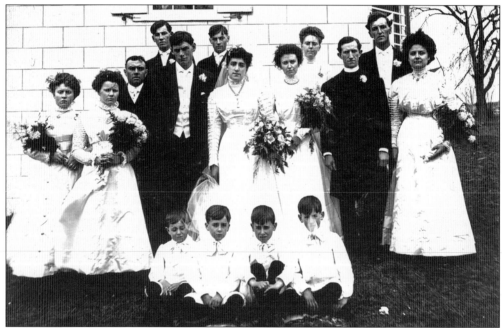

The only wedding picture in the entire collection is clearly rural, but its location is unknown as is the identity of the rather grim-faced wedding party. Two of the female attendants clearly resemble the bride, the other three bear a strong family resemblance. Traditionally Lutheran and Episcopal clergy wore the Roman collar. That the clergyman wearing a boutonniere suggests that he is related to the family.

One

COLLEGE YEARS

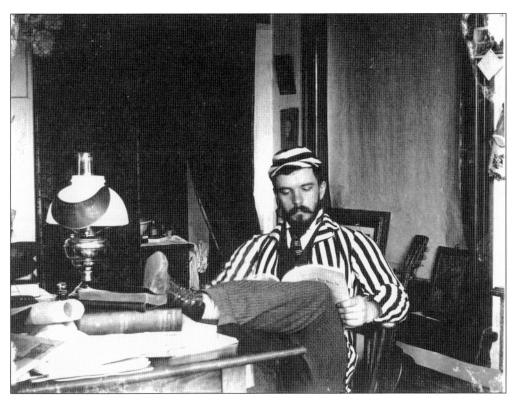

In 1886, 21-year old Henry K. Landis matriculated at Lehigh University to study engineering. Looking older than his years, he wears his freshman cap and blazer while sitting in his dormitory room. Note the kerosene lamp, draped with an eyeshade, to his left.

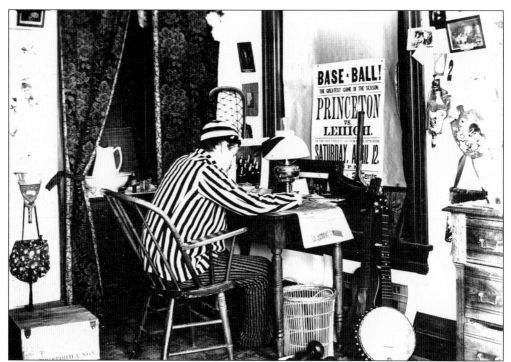

Dorm room interiors demonstrate that while the props and clothing have changed with the times, basic clutter has not. Nor have students stopped sprawling on the bed. Henry K. Landis studies in front of a poster announcing the upcoming Princeton versus Lehigh baseball game. Below, friends play a guitar and banjo duet. The student on the bed has had the good grace to remove his shoes.

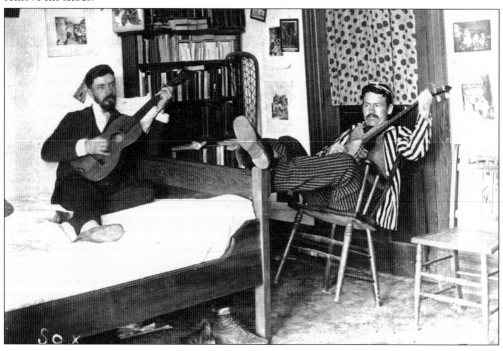

Then as now, occasionally students became ill. Henry recorded a friend who probably had an earache swathed in a warm scarf with an open liquor bottle beside him. The story behind it may have been an interesting one. Henry's caption is enduring, especially at an all-male school as Lehigh was. It is captioned, "Good looking nurses needed." Brother George apparently started Lehigh at the same time as Henry and soon became ill. This, along with a general disinclination towards book learning, led to his dropping out.

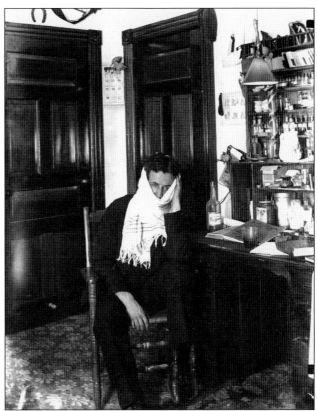

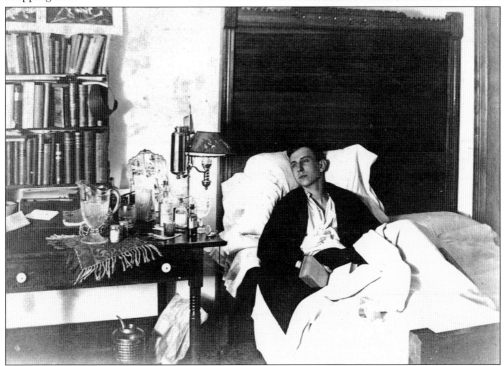

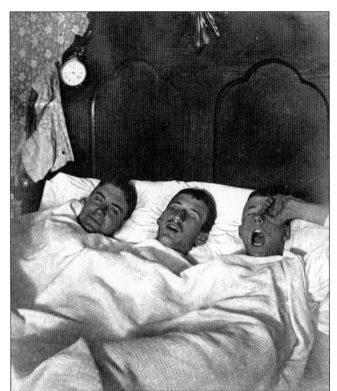

"Three in a Bed," photographed during Henry K. Landis's senior year at Lehigh, is one of the oddest student photographs in the collection. Was this the classic "Morning after the night before"? Henry recorded that this photograph was taken June 22, 1890, at 9:23 a.m.

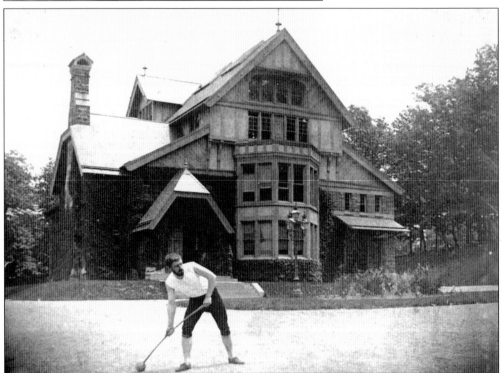

Always athletic, Henry poses with a mallet or club on the Lehigh campus.

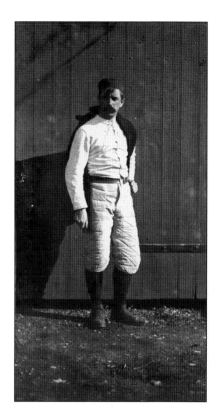

Henry's college career was to be a very active one, in which he pursued many interests in addition to his studies. But central to his years at Lehigh was his devotion to athletic pursuits. It was here that he first learned fencing, a sport he would continue with after leaving school. In the next chapter, he will be seen in much less traditional fencing attire. In the 1880s, football was an elite sport played at elite schools, and Henry always thought himself to be a gentleman.

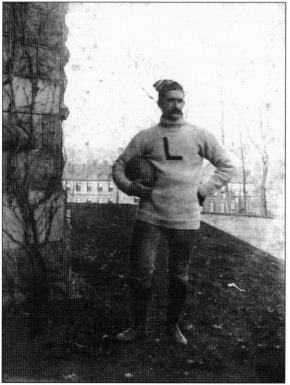

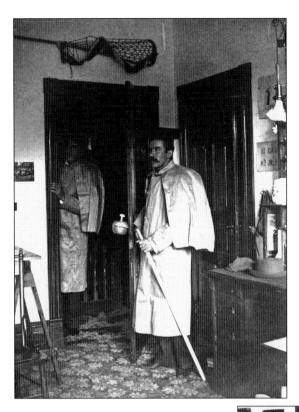

Henry K. Landis is pictured in his dorm room at Lehigh, apparently getting ready for a torchlight parade. Precisely what his costume represents is unclear.

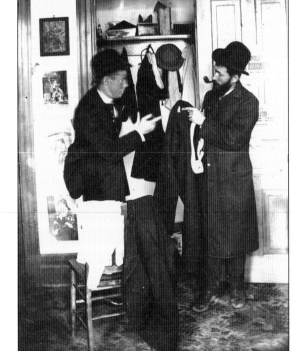

Solomon Levi (to the right) was, no doubt, a clothing merchant in Bethlehem who catered to Lehigh students. He is shown conferring about garments with one of Henry's friends.

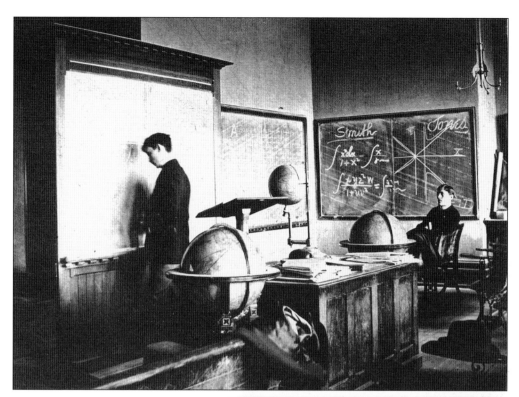

Eager to record everything about his Lehigh experience, Henry photographed all the buildings on campus as well as many interiors. Above, a classroom can be seen, equipped with many globes. Judging from the information on the blackboard, it was also used to teach mathematics, including integral calculus. Below, Henry is photographed in one of the school's high-ceilinged chemistry laboratories.

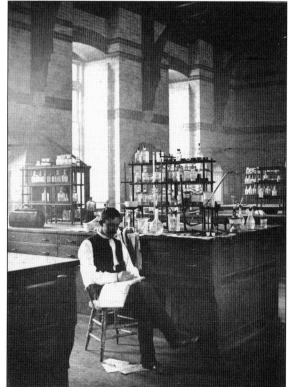

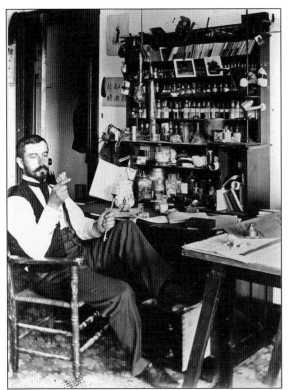

Chemistry was important to the study of mining engineering. In the photograph at left, Henry K. Landis is probably studying qualitative chemical analysis as suggested by the many bottles of reagents on the shelves. In this branch of chemistry, one learned to identify the components of chemical compounds. Below, Henry is operating an extremely accurate balance used in quantitative chemical analysis, where one studied the weights of elements in compounds.

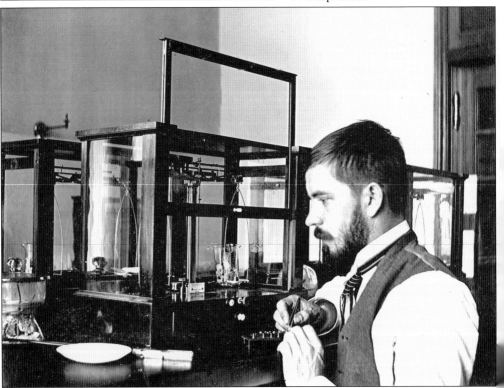

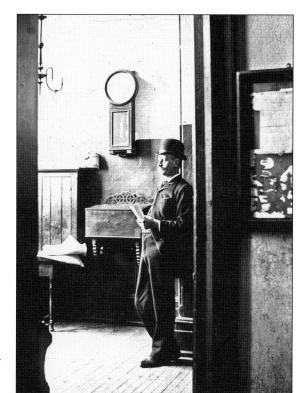

In Henry's many candid photographs at Lehigh University, one can obtain informal glimpses into school life. The formality of ordinary dress is very striking from a contemporary perspective. At right, "Jim the janitor Packer Hall LU" holds some papers. Note his derby hat. Below, students look at notices on a bulletin board. Painted on the frosted glass of the door to the left is important information: "Exam today."

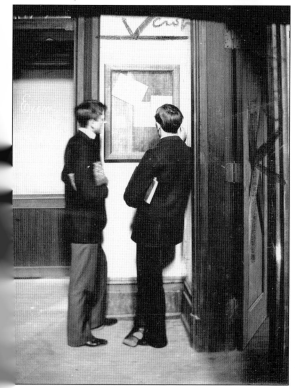

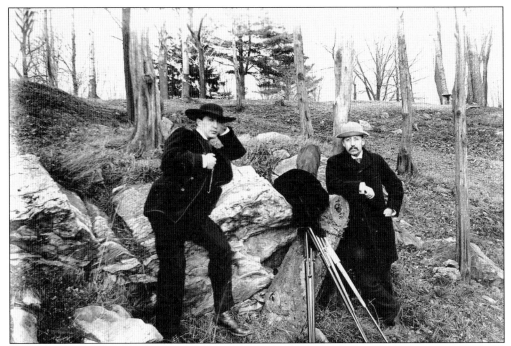

For the sake of posterity, it is important to thank Lehigh University for enhancing Henry K. Landis's interest in photography. The bulk of the historic photographic collection at the Landis Valley Museum was taken and printed by Henry, who was very active with the camera club. Above is his photograph of two club members, "Dodson and Smith." Below, a member is photographed on the Lehigh campus during the winter.

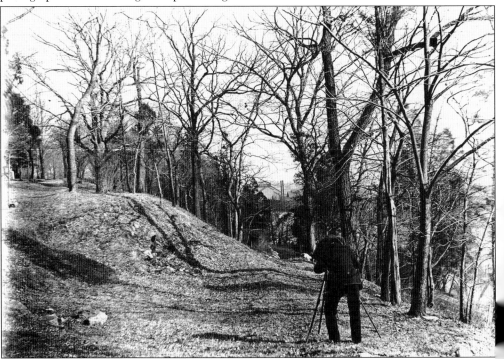

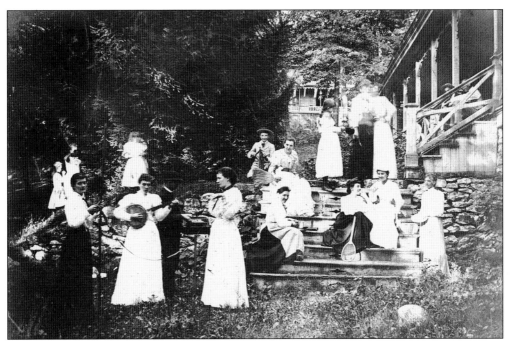

Many of the scenes and actions that Henry K. Landis photographed in and around Bethlehem reveal that he had a wide-ranging curiosity and catholic tastes. Among these intriguing views are the scenes, apparently at a women's school, of many young women resting from tennis, playing a banjo, and other peaceful pursuits. Below, in a scene reminiscent of the popular paintings of John George Brown (1831–1913), Henry photographs street kids in Easton shooting marbles.

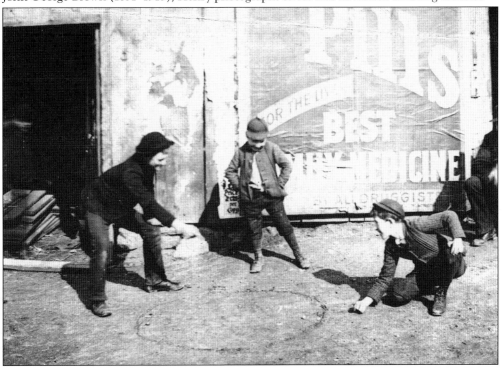

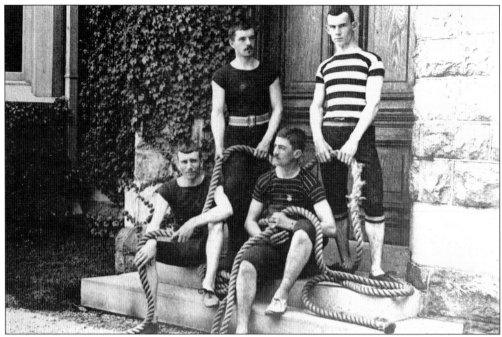

Henry K. Landis apparently took part in many team sport activities. The young men, clad in bathing suits and holding a long rope, were probably life guards. Henry stands to the left in the photograph above as well as below in a group picture of a Lehigh athletic team. Note the young man leaning on a high-wheel bicycle or an "ordinary." Medals that the team won decorate the top of the image.

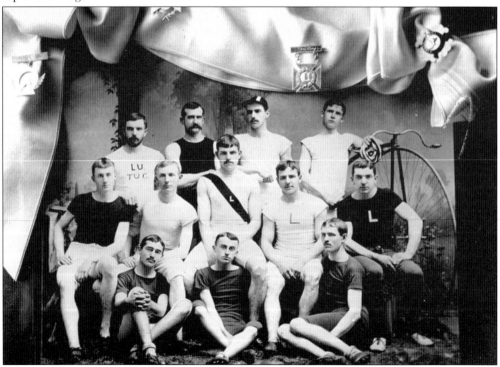

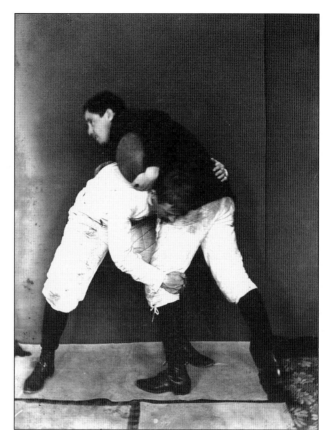

As mentioned earlier, football was a new sport at upper-class schools in the 1880s. Henry himself played, and he did a series of photographs of different plays and moves. In its early days, players did not wear helmets nor did they wear padding. These were added to football when the game became more popular and increasingly violent in the 20th century.

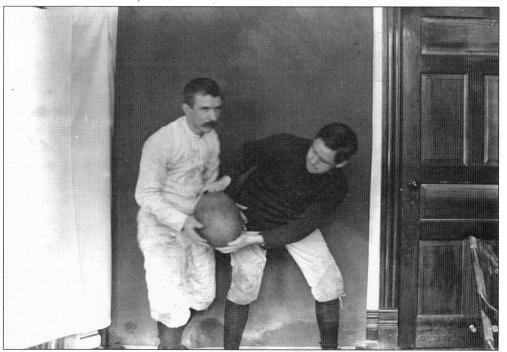

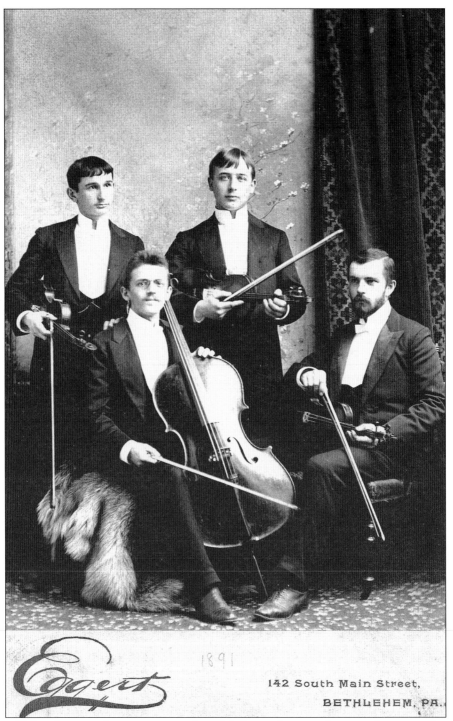

1891

Eggert

142 South Main Street,
BETHLEHEM, PA.

Henry K. Landis was a fine musician and would play with musical groups during much of his adult life. As a gentleman musician in a formal age, he had his own white tie and tails. He and his fellow members of the Lehigh String Quartet posed for a formal portrait by a Bethlehem photographer. Henry is seated to the right.

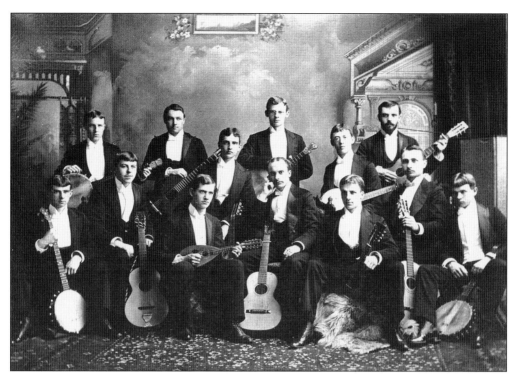

Lehigh University had a very rich musical life during Henry's student years. In addition to playing in the string quartet, he was a member of the banjo and guitar club, seen above. He holds a guitar, standing at the right. Below, with a violin in hand, he is seen in the Lehigh Orchestra.

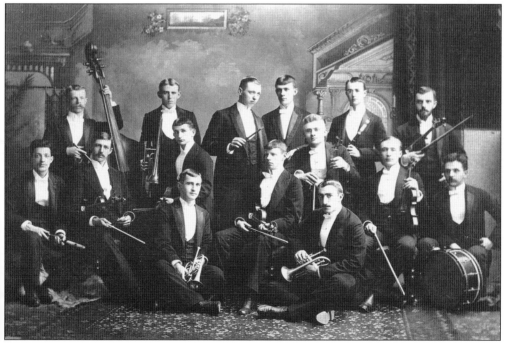

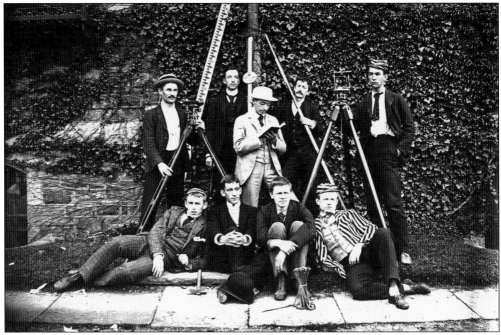

Surveying was one of the subjects that Henry K. Landis studied. The instructor stands in the midst of a group of students, several of whom were freshmen. They can be identified by their beanies.

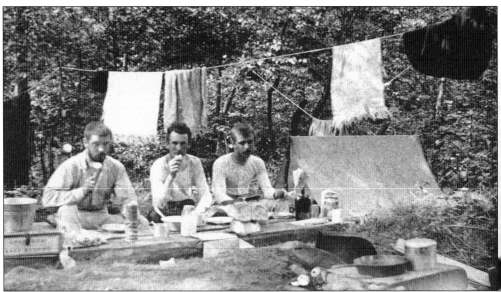

From July 30 to August 10, 1888, Henry K. Landis, H. Justin Roody, and George Diller Landis (left to right) canoed and camped along the Juniata River. Here they are shown having breakfast at their Mountain Pine Camp, five miles below Lewistown, Pennsylvania. Roody (1856–1943), seven years older than Henry, had met "Lad" (as Henry was known) when he was young Landis's teacher at the Neffsville School from 1883 to 1885. Roody would eventually receive a doctorate and become a science professor at Millersville State Normal School. He was to be an intimate lifelong friend of Henry's.

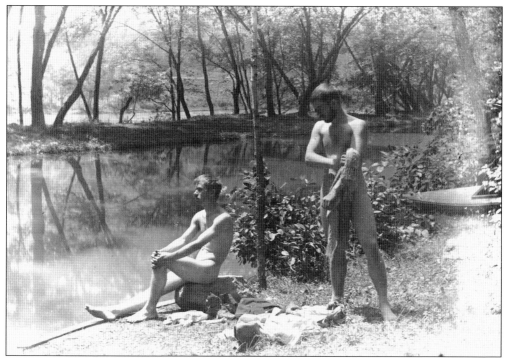

At Jack's Narrows on the Juniata River, the canoeing party decided to cool off by taking a dip. Henry recorded what followed: "While in swimming a carriage passed and the horse, hearing us talk, stopped and it was with difficulty that he was obliged to move, the ladies inside trying to urge him on wanting and yet not wanting to look. We didn't hide, arguing that if they didn't want to see us they were not obliged to look at us, and if they wanted to look at us we had no objections."

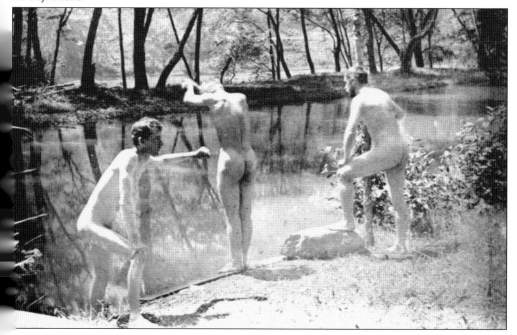

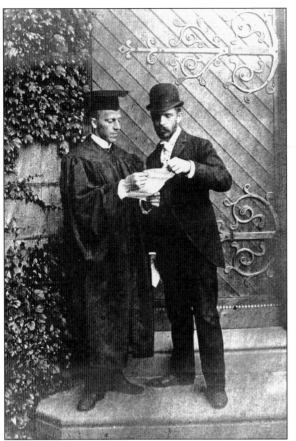

In 1890, Henry K. Landis graduated from Lehigh University with a degree in mining engineering. He was 25 years old and was anxious to look like a serious mature man. At left, he talks to one of his professors, and below he poses with his fellow graduates. Bethlehem sprawls beyond the Lehigh campus. Note how Landis always wanted to make sure that posterity recognized him.

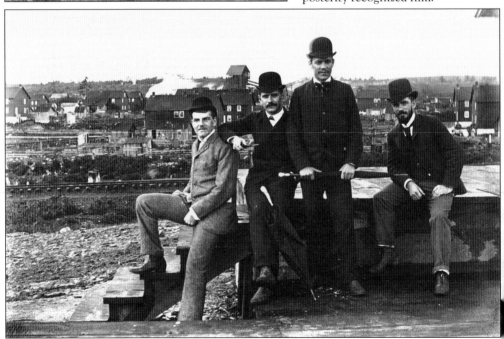

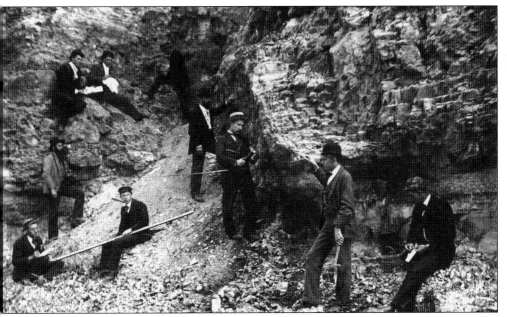

After briefly working for the Bethlehem Steel Corporation, Landis became a professor at the Missouri School of Mines in Rolla, Missouri. In the picture above, "Prof. Landis" can be seen on a class trip "Along the Gasconade" in 1893. While there he also played with the school's "Football Club." Seated in the middle, 28-year-old Landis holds the ball.

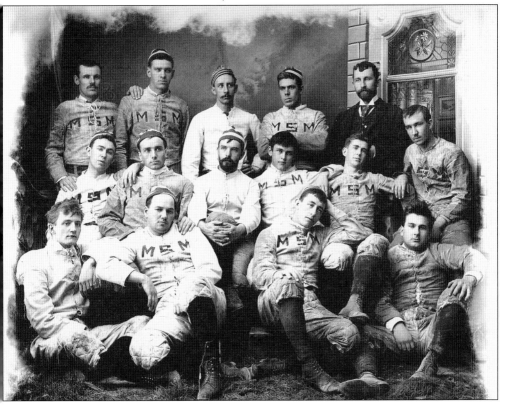

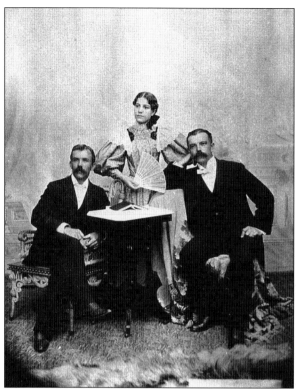

Nettie May Landis was very important to her older brothers. Henry K. Landis especially wanted her to be a lady. She in turn adored him and whenever possible, shared his enthusiasms. Here she poses in a trick photograph which features Henry, Nettie, and Henry.

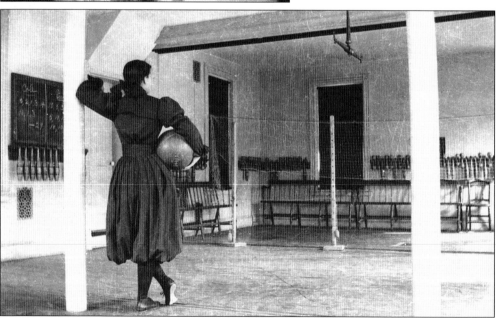

Planning to be a teacher, Nettie May studied at Millersville State Normal School from 1893 to 1896, but had to withdraw because of health reasons. Not wanting her to end her education, Henry K. urged her to attend St. Catherine's School in Brooklyn, near where he lived. Here she could take part in moderate exercise. Her fragile health, however, forced her to withdraw after a few months.

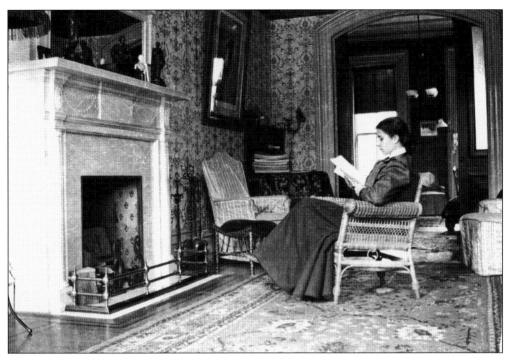

Life at St. Catherine's School was polite and well-mannered. Nettie May's residence hall featured a well-appointed parlor ideal for a young lady to sit and read. Among her studies was art. Here she learns to draw from plaster casts. After her stay at the Brooklyn school, art would remain an important part of her life. She would become an accomplished porcelain decorator and did many oil paintings, some of which decorate her family home, now a museum.

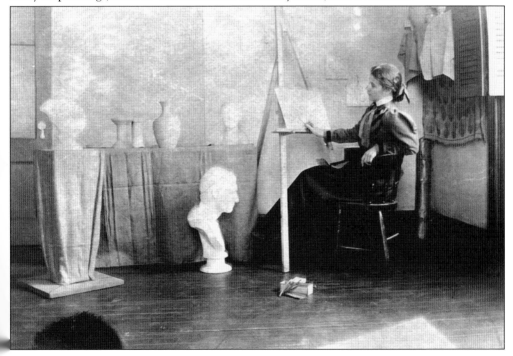

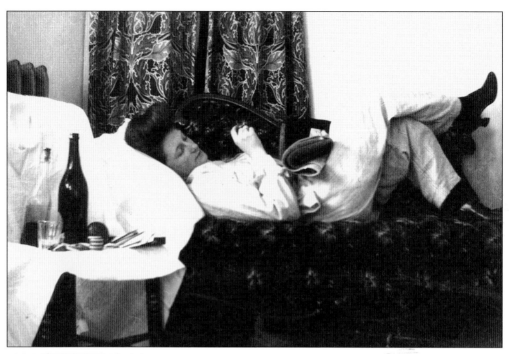

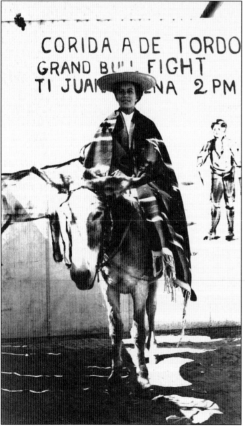

Nettie May Landis suffered from tuberculoses and was often ill. Reclining on a couch, she was photographed by Henry K. Landis; he labeled it, "Nettie Sick." As a last ditch attempt to regain her health, the family sent her west. She even traveled to Tijuana, Mexico, where the tourist picture was taken. She died in St. George, Utah, in May 1913. Her father, Henry H. Landis, wrote tearfully in his journal, "I was So overcome that I cannot think or do anything . . . I knew the tears were rolling down my cheeks . . . Oh what I would give to have my Nettie here alive and well."

Three

NEW YORK CITY AND PORT WASHINGTON

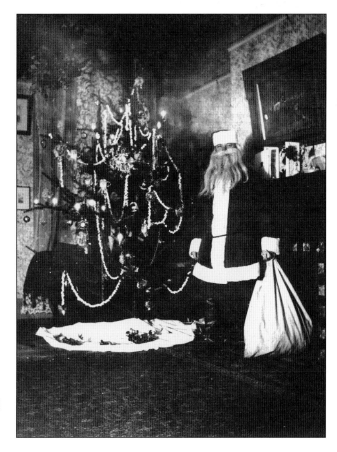

Henry K. Landis would live and work in New York City from the mid-1890s into the 1920s. Never marrying, he led a full life, however, including acting as Santa Claus at a party around 1900. The setting is probably a friend's parlor.

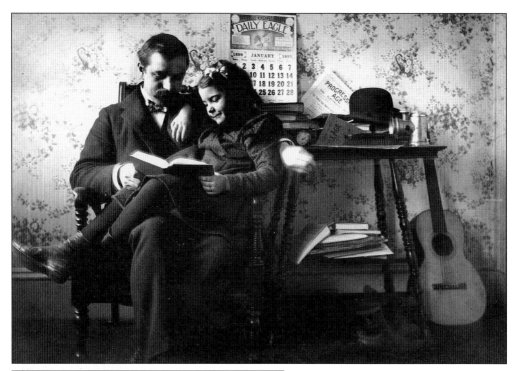

Bachelor Henry K. Landis was photographed in a number of oddly domestic scenes usually draped in pre-pubescent girls. The photograph above was, according to the calendar, made in January 1899 while Landis was living in Brooklyn. Landis titled the photograph at left "After Work." The children probably belonged to his landlord.

As was common among upper-middle class bachelors, Landis lived in boarding houses. These were respectable establishments where Landis would have his own sitting room and bedroom. Meals would be taken in the dining room. Servants cleaned and did laundry. The photograph above is in Landis's sitting room. Note his bicycle and musical instruments. The people (left to right) are identified as "Landlady HKL Scovill" and James Scovill, one of Landis's close friends. Apparently an amateur musician, as was Landis, in the photograph below, Scovill is seen in his sitting room. Note the violin on the settee and the nude photograph on the fabric-draped mantle.

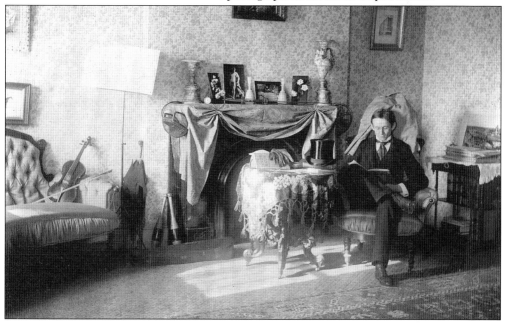

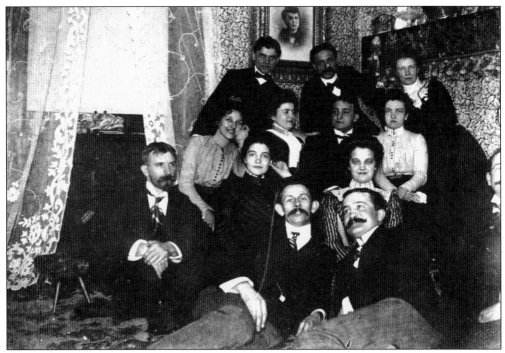

Always gregarious, Henry K. Landis loved to entertain and attend parties. He photographed this respectable party scene early in the 20th century. No one is touching, and there are lace curtains at the window.

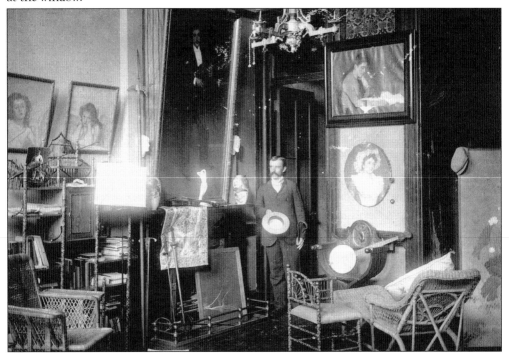

Interested in the arts, Landis had opera-singer friends, and he is pictured viewing the studio of an artist named Gordigiana (possibly Eduardo, 1866–1961) in New York City.

Landis poses in his bedroom at 263 West 72nd Street in New York City in November 1908. He took several views of the room. The image at right, which includes the chair he is sitting on, he entitled "Middle Class Life in New York." Note all the bric-a-brac around him. His pitcher and bowl are in the distance and a pair of shoes, with shoe trees, is on the stand next to the chair. Note the throw pillow with the "Gibson Girl" image on it.

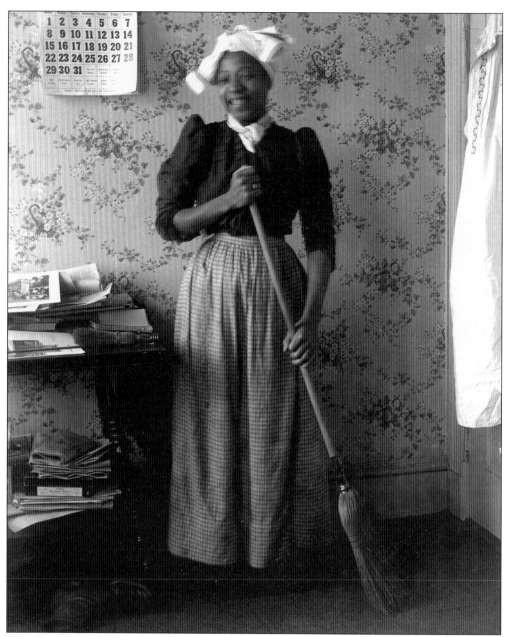

Inexpensive domestic help was very important to polite New York middle-class life in the pre-electric appliance age. Henry K. Landis photographed an African-American maid in his Brooklyn boarding house in 1899.

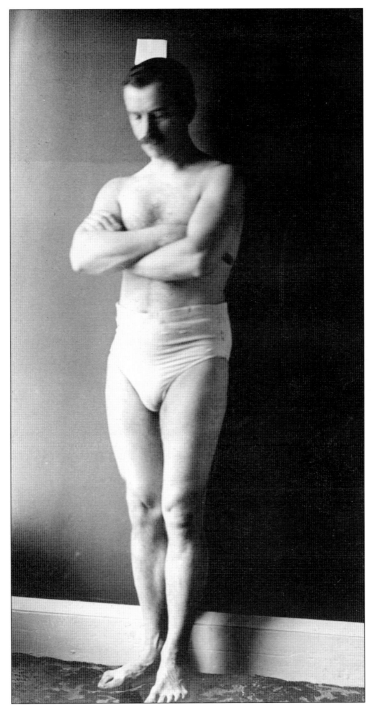

Through his mid-40s, at least, Landis was very keen on physical fitness. Accordingly this was an interest he would continue in New York City. He posed for this pensive portrait in 1903, when he was 38 years old. It is not known whether this and the following figure studies were photographed by Landis himself using a delayed shutter mechanism or by a fellow physical culture enthusiast.

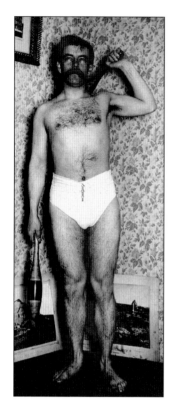

Henry K. Landis was devoted to exercise. Among his equipment were "Indian clubs." The studies on these two pages are from an album entitled "Anthropometric Studies," which includes a table listing Landis's weight, height, and muscle measurements from the time he was at Lehigh University through his late 30s. There was little variation. Fencing was also one of his enthusiasms since his college years. One assumes he wore more clothing during matches. This photograph was taken in November 1898.

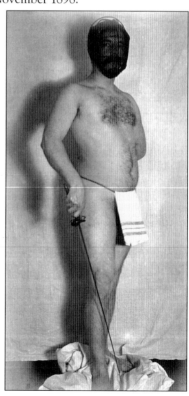

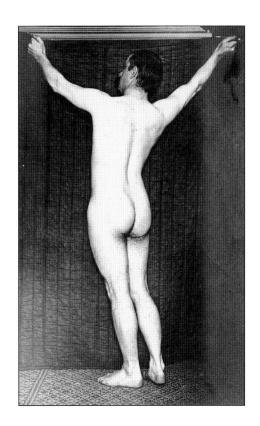

Using some sort of stretching device, Landis poses in a photograph taken in January 1896, when he was 31. The photograph below, done in 1898, shows him in a classic pose displaying his musculature.

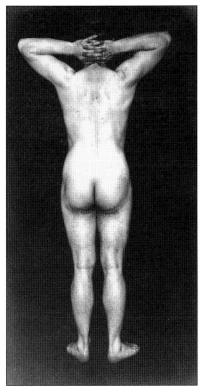

Henry K. Landis moved between Manhattan and Brooklyn several times during his years in New York City. In 1894, he was photographed in Prospect Park in Brooklyn, where he often went to bicycle. The bridge behind him is part of the elegant ornamentation called for by the park's designer, Frederick Law Olmstead (1822–1903), who had earlier designed New York City's Central Park. In the Columbia Heights neighborhood of Brooklyn, where he was living, he photographed this young lady in an elaborate hat posing on an extraordinary iron balustrade.

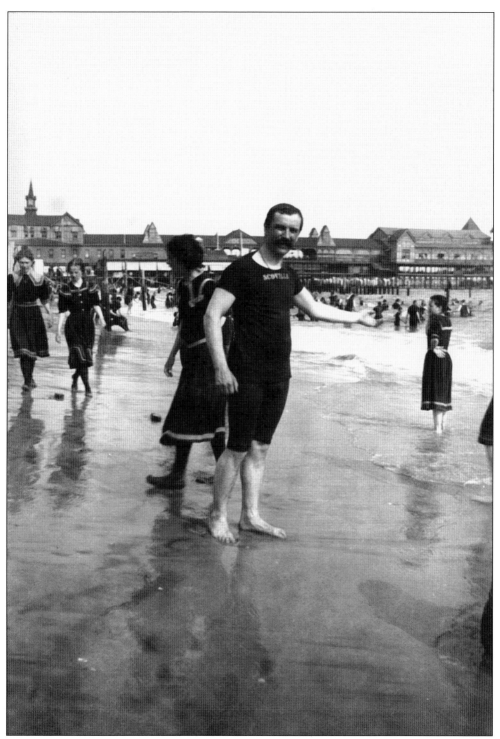

"By the Sea, By the Sea, By the Beautiful Sea," went the lyrics of an early-20th-century popular song. Landis, in a fashionable bathing costume, poses at Coney Island in Brooklyn when it was a middle- and upper-class resort featuring grand resort hotels.

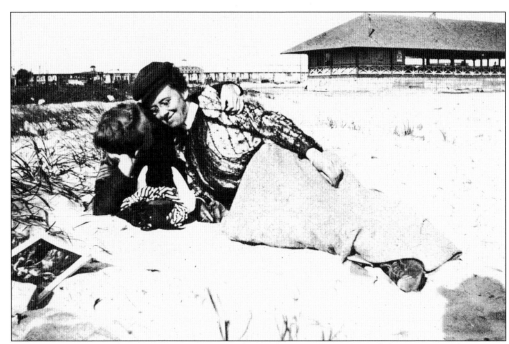

Was Henry K. Landis a voyeur? He certainly took a number of candid pictures of lovers on the beach at Coney Island and elsewhere. On the reverse of this photograph above, he wrote, "That is a very good sign that she's your tootsie-wootsie." The term had been popularized recently in a song that went "Meet Me in St. Louis, Louis, meet me at the Fair . . . I will be your tootsie-wootsie." There is no caption on the photograph of the two bicyclists taking a break on the beach.

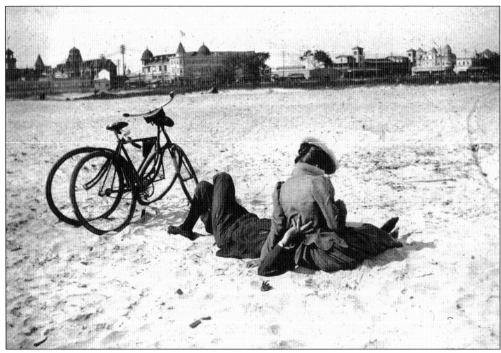

One of the most interesting Coney Island scenes shows an oddly-clad couple walking down the beach. The caption on the back is the coy, "Holding their own."

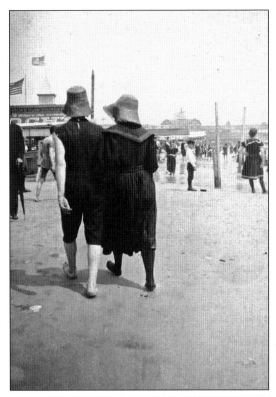

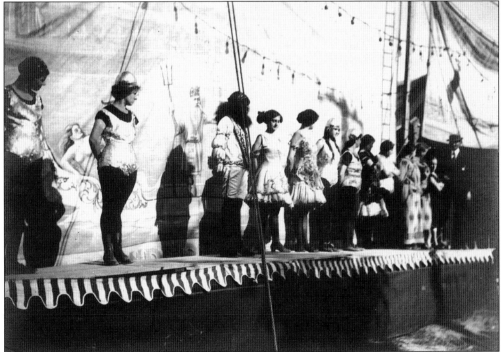

Sideshow performers have been a staple at Coney Island since the 19th century. These entertainers, including a bearded lady, were photographed by Landis, around 1900.

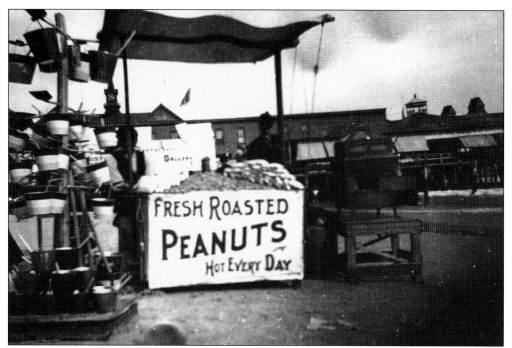

Refreshment vendors have long been a part of the beach scene at Coney Island. Before the construction of the Brooklyn resort's famed boardwalk, sellers set up their stands right on the beach. While peanut stands remain a constant, absolutely fresh milk is no longer available. That cows on the beach was a common sight is attested to by the nearby couples not paying any attention to the bovines' presence.

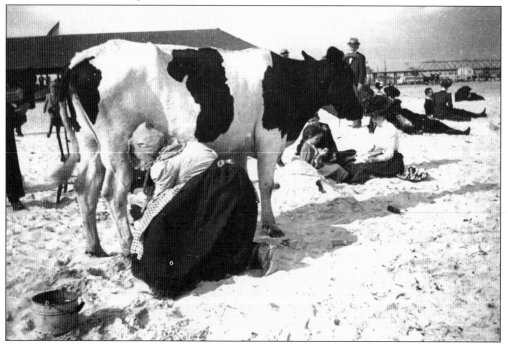

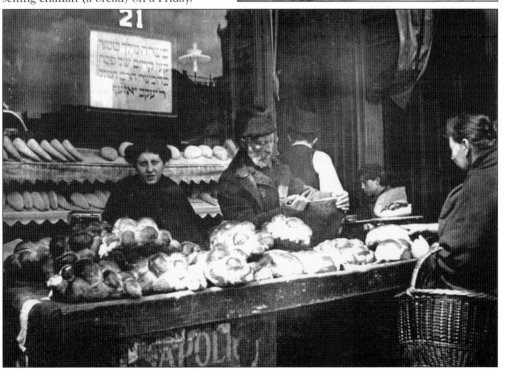

The streets of New York City provided many fascinating, unusual, and exotic scenes for Lancaster County–raised Henry K. Landis. "Coming of the Teams" is the most animated of his candid shots and very much reflects the influence of urban photography pioneers like Alfred Stieglitz (1864–1946) and Edward Steichen (1879–1973). Landis was fascinated by the street life of New York City's teeming lower East Side, where he photographed these Jewish vendors selling challah (a bread) on a Friday.

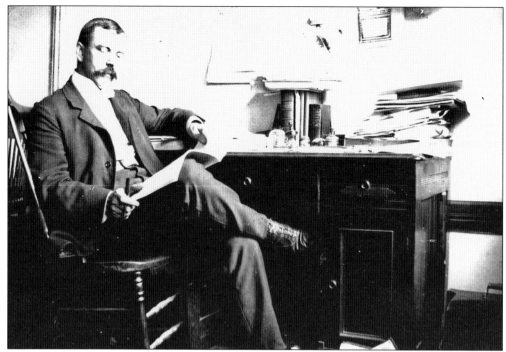

Editing trade journals was Henry K. Landis's career when he lived in New York City. His longest affiliation was with a magazine *Progressive Age*, which changed its name to *Gas Age*. The editor looked very much the Edwardian gentleman sitting at his desk. The clutter on the "Editor's Desk" was much less impressive.

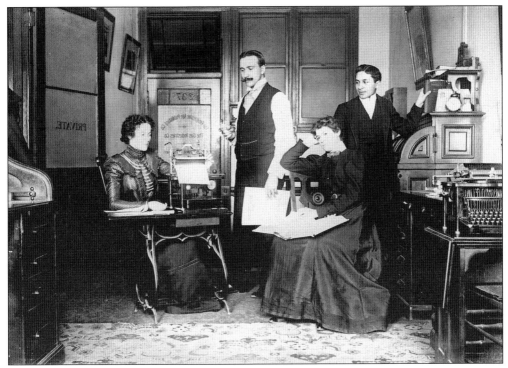

Landis poses with his office staff at *Gas Age*. Note the typewriter and the other up-to-date office equipment.

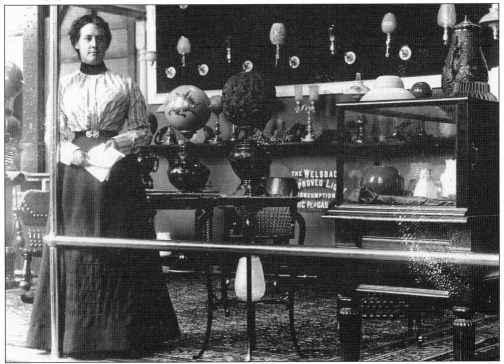

Gas Age's outer office featured a display of some of the products used for modern gas lighting.

"Sub surface gas mains in New York" is an impressive industrial photograph foreshadowing the better known studies of pipes by Charles Sheeler (1883–1965) or Ansel Adams (1902–1984).

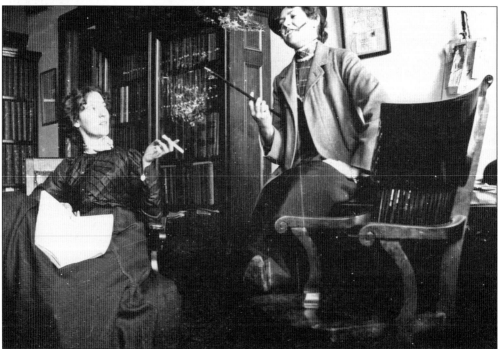

It was certainly not all work and no play at *Gas Age*. "Miss Riley, stenographer" at the left poses with a co-worker. Both smoke.

94

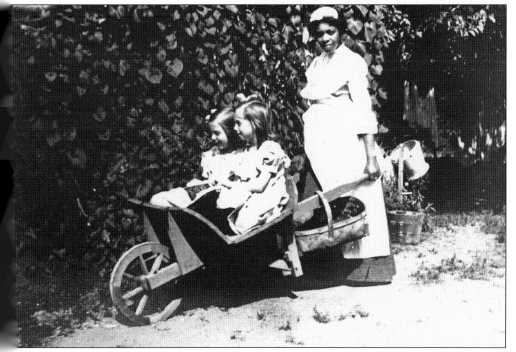

Like many New York residents in the summertime, Henry K. Landis fled the city whenever he could. His favorite retreat was Port Washington on Long Island. As in New York City, at first, he lived in a series of boarding houses. Then he moved to a houseboat. Before his parents' deaths, he even bought land at Port Washington, intending to build a house, but he never did. Elsie and Lucy were the children of his favorite landlord at Port Washington. They play on the lawn in front of their home and enjoy a ride in a wheelbarrow being provided by a not-overly happy servant.

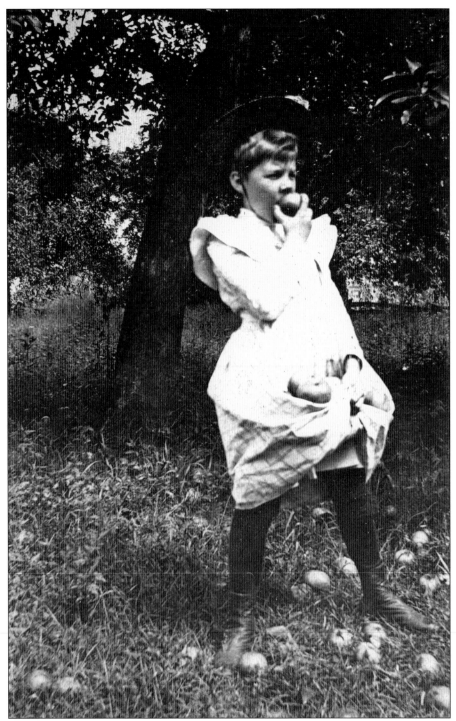

Like mathematician Charles Dodson (1832–1898), who is better known as Lewis Carroll, the author of *Alice in Wonderland*, Henry K. Landis enjoyed photographing little girls—often in informal poses, including those in their underwear. The most engaging of these special pictures shows Elsie who "was strong on apples."

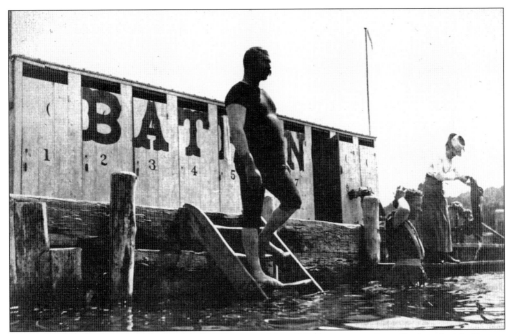

Swimming and boating were among the charms of Port Washington, a friendly but decidedly not chic resort. "Ryder and his beach" shows the master of one of the local bathing establishments. Down the beach a number of folks, including men, women, and children, frolic in the water. Note the women's turbans designed to keep their hair dry.

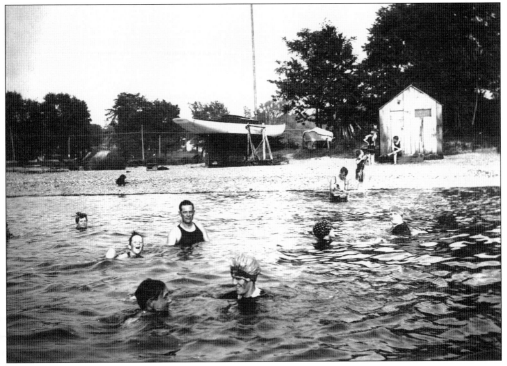

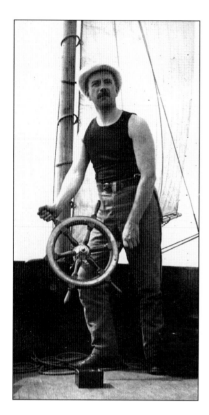

Sailing was Henry K. Landis's particular summer love. At left, he is seen as captain of *No. 7* in 1903. He would own several sail craft, including the *Echo*. Below he poses on deck in his swim suit, pipe in mouth. This photograph was probably taken the same day as the one of him and his brother George Diller Landis seen on the next page.

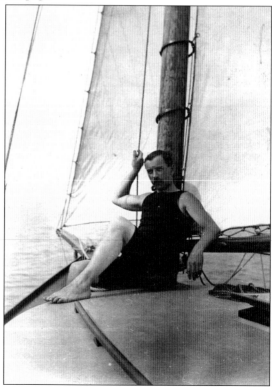

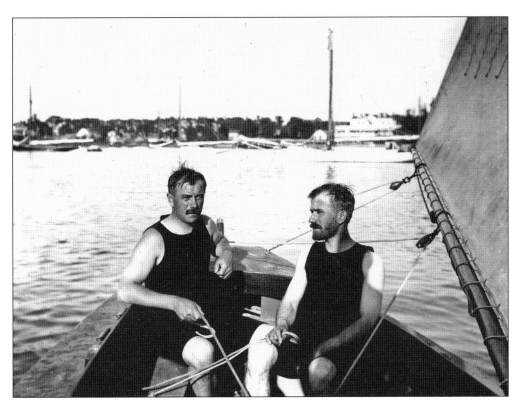

The Landis siblings were all very close. Henry frequently visited back home and his brother and sister visited him in New York City and at Port Washington. Above, "HKL & GDL in 'No 7'" records a visit by brother George. Below on the deck of a sailboat, Nettie May strikes up a pose that almost looks like it could have been painted by Philadelphian Thomas Eakins (1844–1916).

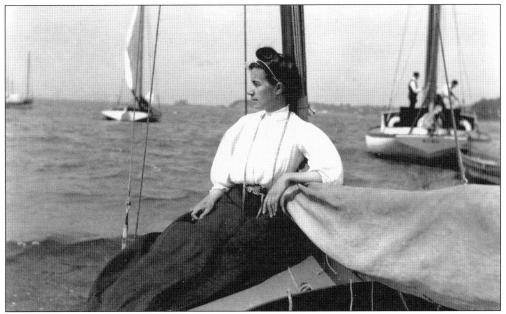

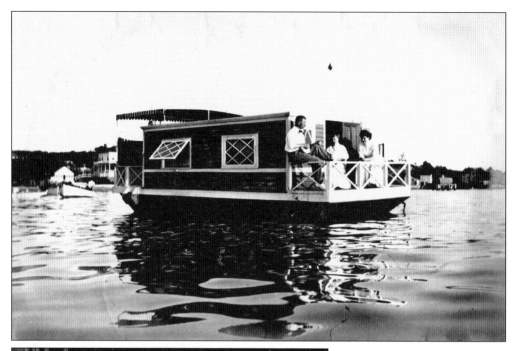

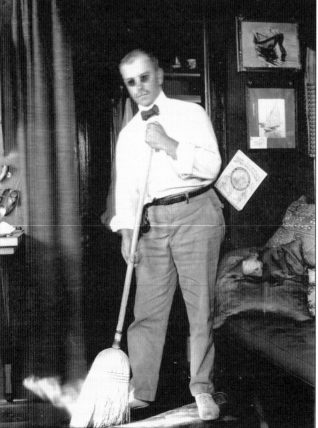

By the early 1900s, Henry K. Landis acquired the first of his several houseboats. The *NOD* was photographed in 1909 with several guests on the rear veranda. Landis, inexplicably wearing sunglasses, sweeps the interior. Note the oriental rug-clad couch behind him and the photographs on the wall.

Landis probably took this photograph of George Landis asleep in the "Port Bunk on Echo." The large stoneware jugs held water.

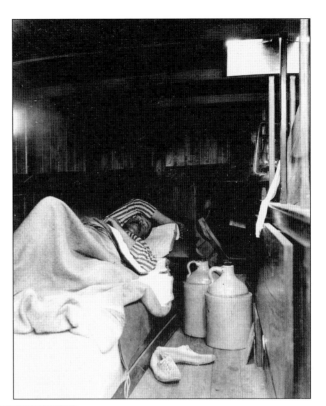

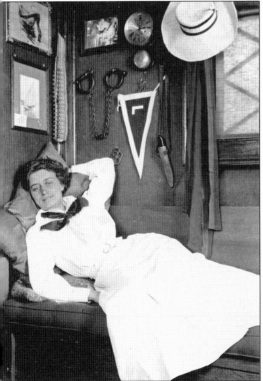

A young lady, possibly an employee of *Gas Age*, poses comfortably aboard the houseboat *NOD*. Among the items hanging on the wall are a Lehigh University pennant and, more mysteriously, a pair of shackles.

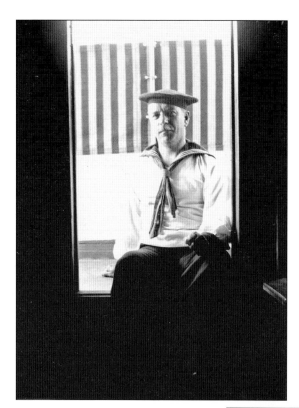

Always interested in theatrics, Henry K. Landis apparently appeared in an amateur performance of a famed Gilbert and Sullivan operetta. This photograph is captioned "H.M.S. Pinafore bosoms mate." It was photographed on his houseboat.

While evidence shows that Landis appeared in *H.M.S. Pinafore,* a series of photographs suggest that he would have preferred to have been in *Pirates of Penzance,* or perhaps he was smitten by *Treasure Island.* Here meet Pirate Henry.

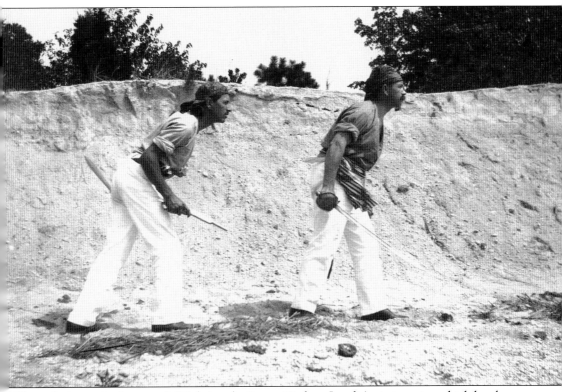

The melodramatic photograph "Sighting the Enemy" is from Landis's pirate series, which he also used in a manuscript he assembled. His fellow buccaneer is his longtime Lancaster friend John Witmer Jr., visiting him on Long Island.

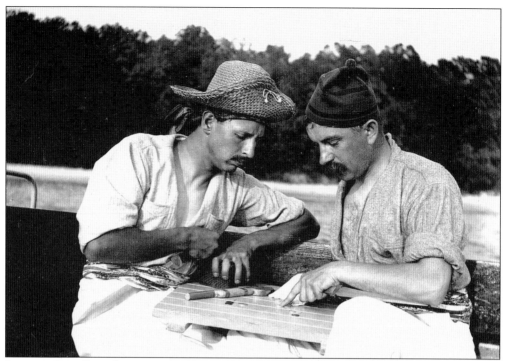

In a very friendly and intimate pose pirates, John Witmer Jr. (left) and Henry K. Landis, play a board game on the deck of their "pirate ship."

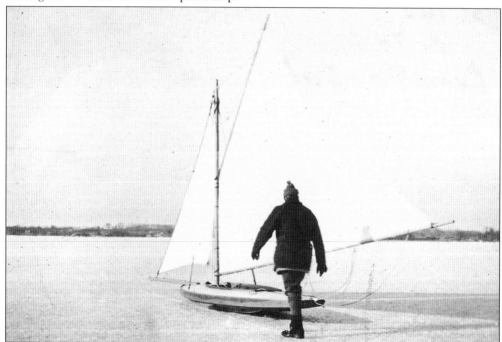

The sport of ice sailing attracted Landis back to Port Washington in the winter. Here he approaches his ice yacht *Pumpkin Seed*. By the time he retired to Landis Valley, Henry had sold the *Pumpkin Seed*, his other boats, and his land in Port Washington.

Four

THEIR OWN MUSEUM

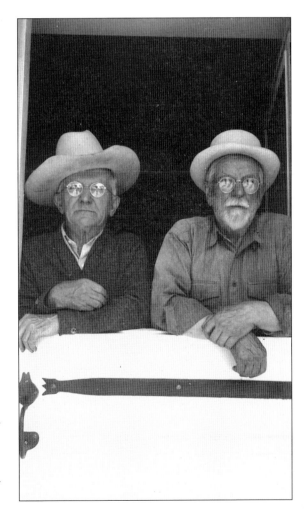

George Diller and Henry K. Landis
pose in a split or "Dutch" door at their
museum in the late 1940s. While the
brothers had actively collected all their
lives, the museum was the creation of
their mature years and dates following
Henry's return to the farm in 1924 to
help with their elderly and increasingly
frail parents.

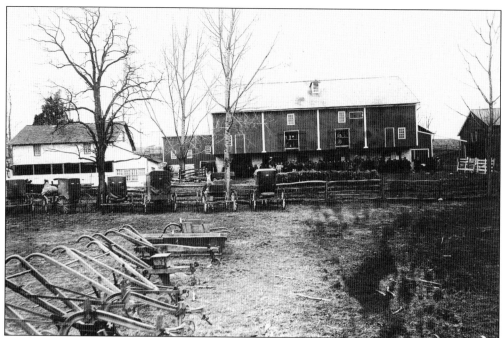

Much of the collection of what would become the Landis Valley Museum was assembled through country auctions. By 1910, George and Henry Landis were beginning to collect actively "their purchases reflected both their interest in everyday Pennsylvania Dutch history and their middleclass pocketbooks." Old-time collectors would have called them "nickelmen" because they often bought assorted lots of odds and ends that nobody else wanted. This is how they acquired many of their butter prints, baskets, and cookie cutters. Yesterday's trash is today's treasure. A typical farm auction is seen above around 1935. The auction scene below is identified as the "Stoltzfus Auction, Washington Inn, Churchtown, PA, May 8, 1936."

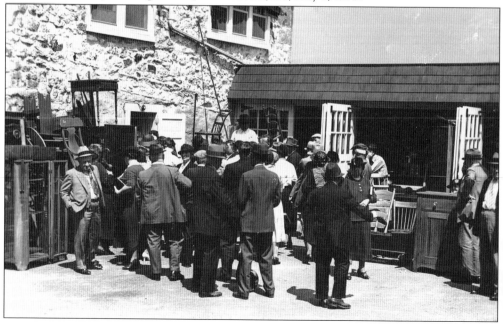

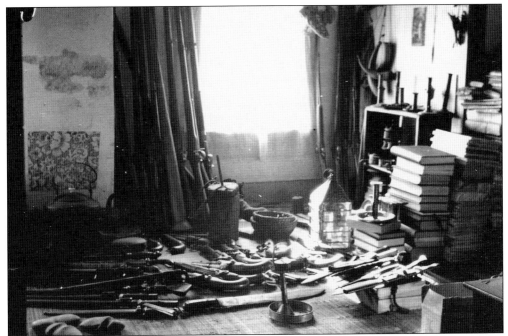

The brothers were very haphazard in storing their collections. They stuffed them in any available nook and cranny. It is only now in the 21st century that their vast collection is finally (mostly) catalogued and stored appropriately. Above, Henry describes the chaotic space as the "Museum in Residence Attic in 1924 and Before." Below is a view of the second floor of the garage as it appeared in 1928.

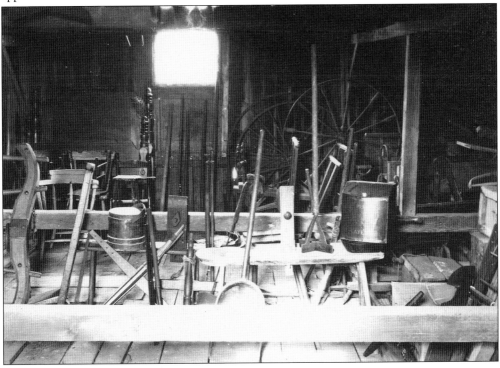

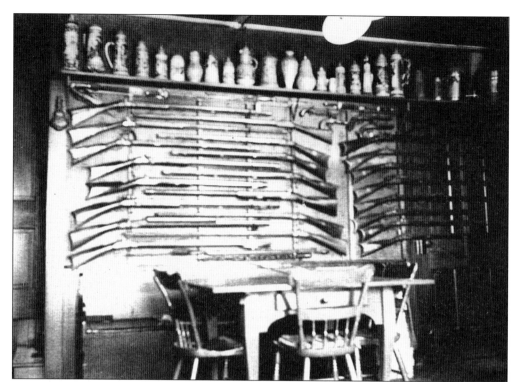

After their parents' deaths, the interior of the family house changed. George Landis moved much of his collection of historic firearms into the dining room along with his and Henry K. Landis's collection of mugs and tankards.

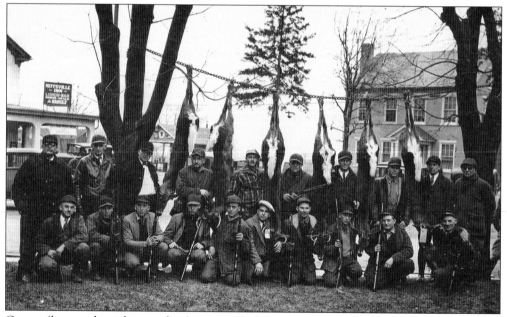

George (last on the right, standing) poses with fellow members of the Neffsville Hunting Club along with their trophies near the Neffsville Inn in the fall of 1930. Neffsville is several miles from Landis Valley.

George's interest in historical weaponry evolved from his passion for hunting and fishing. His first purchases of hunting and fishing paraphernalia were items for use. Gradually with the urging of Henry, he began to amass "Old guns" and "stuff." Eventually he evolved into an authority on local antique guns, especially the Pennsylvania or Kentucky long rifle, which may have been developed along the nearby Conestoga Creek. Here George is seen loading a rifle.

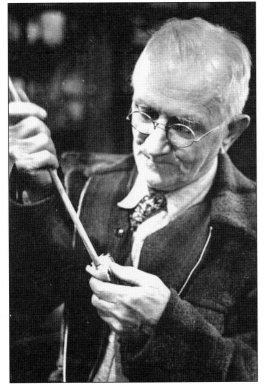

Henry Landis loved animals and curious relics of the past. He photographed this "Hex Totem" on a farmstead in the 1920s. Made of painted stone, Landis was unable to acquire it for his collection.

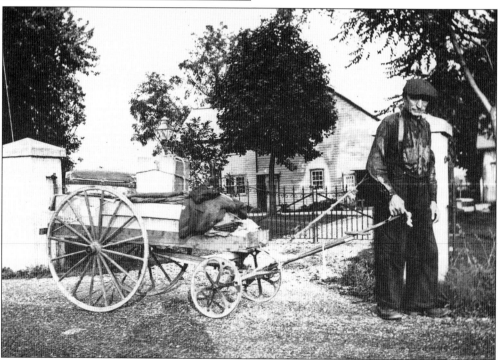

When an "itinerant" showed up at Landis Valley with "a trailer," Landis made sure to record the event in the 1920s.

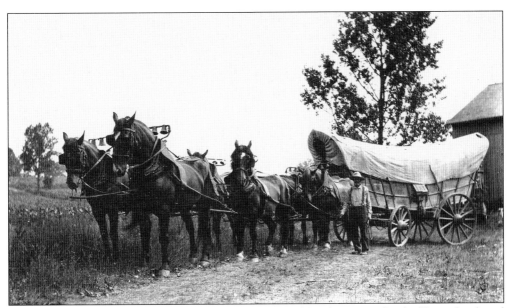

Both brothers were fond of Conestoga Wagons, the famed freight carrier that had been developed locally. The characteristic sway bottom kept loads from shifting. Whenever possible, they liked to arrange to have teams hitched to their wagons, which were most commonly drawn by teams of four or, occasionally, six horses. Smaller versions might also employ oxen power.

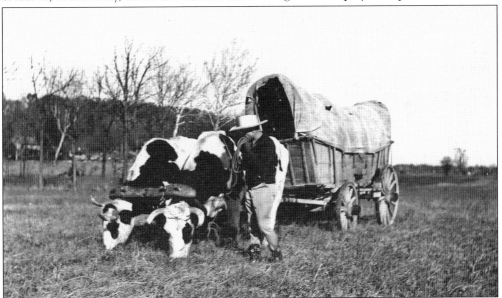

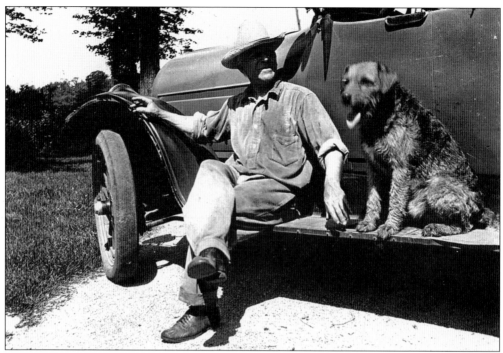

Both George and Henry K. Landis drove and owned automobiles. Their father, Henry H., noted in his diary that automobiles were being sighted regularly at Landis Valley by pre–World War I days. These snapshots of George and Scotty were taken by Henry K. in 1926, on the grounds of what was then called the "Landis Valley Barn Museum."

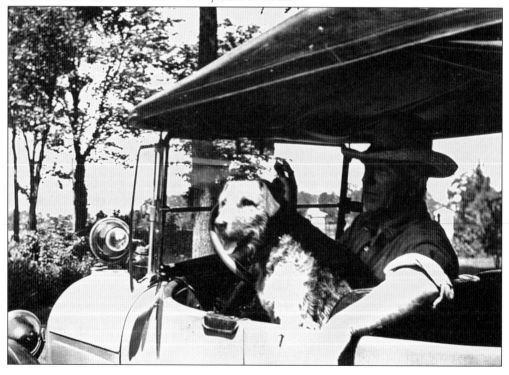

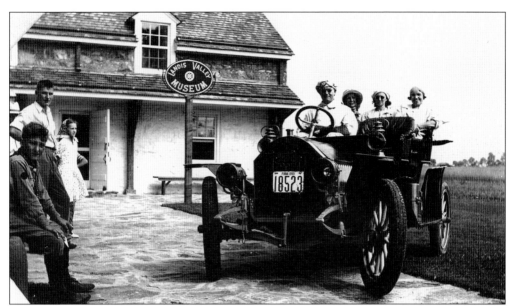

In the 1940s, Henry K. recorded "An Early Car Visits the Museum." The 1909 Ford had its original license plate. Fascinated by the vehicle, Henry K. posed behind the wheel. The backdrop is the new stone tavern, only recently completed thanks to the Oberlander Trust, which helped to develop the museum before it was acquired by the Commonwealth of Pennsylvania.

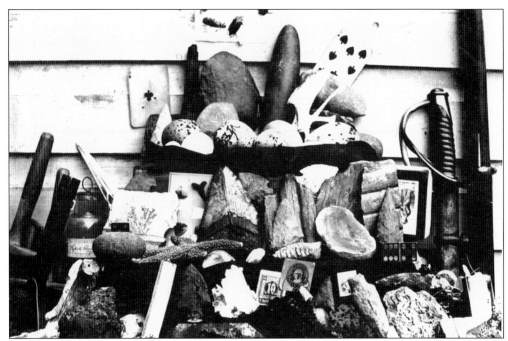

Natural history specimens were important to the Landis brothers, who collected them since childhood. This early museum assemblage includes geologic and botanical specimens, birds eggs combined with historical artifacts. Many of the brothers' natural history collection and library have been disbursed.

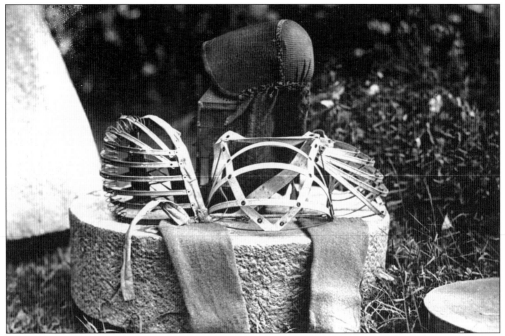

Henry K. Landis liked to create vignettes drawn from the collection, which he would then photograph. "Here," he wrote, "is a bustle and waterfall frame, a black bonnet and home knitted stockings." They are illogically displayed among the brothers' millstones.

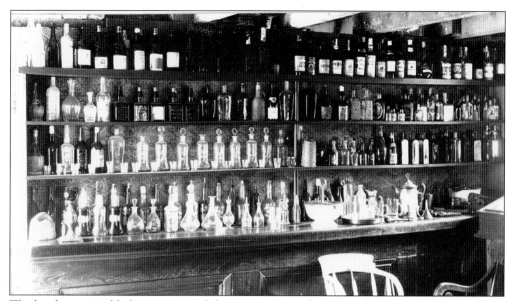

The brothers assembled temporary exhibits in a variety of venues. Above is "The Landis Valley Hotel bar, made 1856 with exhibit of bar bottles made about 1928." Today the Landis Valley Hotel is part of the museum. The present bar is not the original, which had been removed in a later renovation, perhaps when the hotel housed "Louie's Bar." The room exhibition was shown at Lancaster's Watt and Shand department store March 2 to 12, 1932.

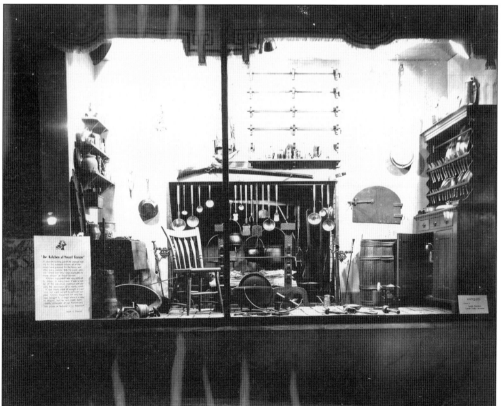

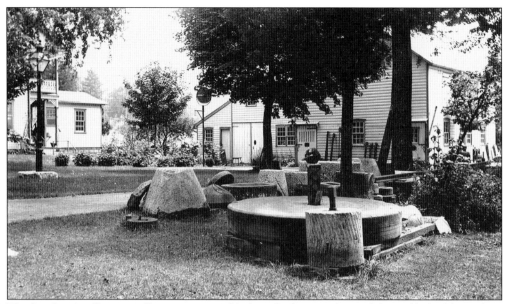

The brothers' mill stone collection was jumbled on the lawn in front of the stable building when this postcard view was made in 1941.

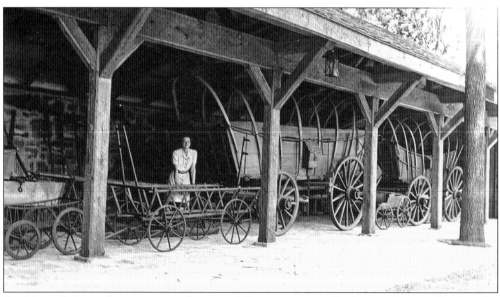

A visitor admires a farm wagon under one of the stone wagon sheds recently completed at the time this photograph was taken in 1941. Used for many years for display, historic vehicles are now protected out of the weather.

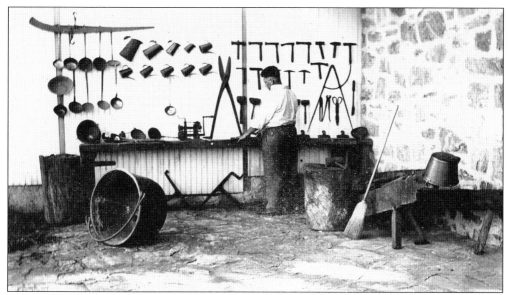

Many metal artifacts were displayed by the brothers in the open. Any wall would do for display. This photograph probably dates from the 1940s.

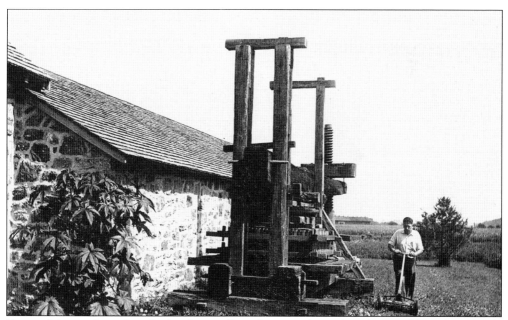

Some of the artifacts that the brothers collected were so large that they could not be properly cared for. One of these was a cider press that Henry K. Landis photographed in the 1940s, shortly after the wagon shed was completed. Because of weathering, only the huge wooden screw, now safely housed, remains.

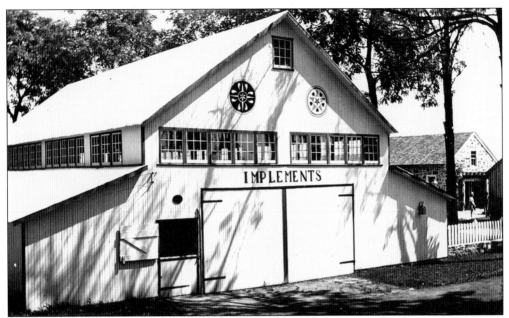

The Landis brothers built what is now called the "Yellow Barn" as their first new "Barn Museum" structure, using materials rescued from the barn on the Jacob Landis farm. After the stone wagon sheds and the tavern were added in the early 1940s, the barn became the "implements" building.

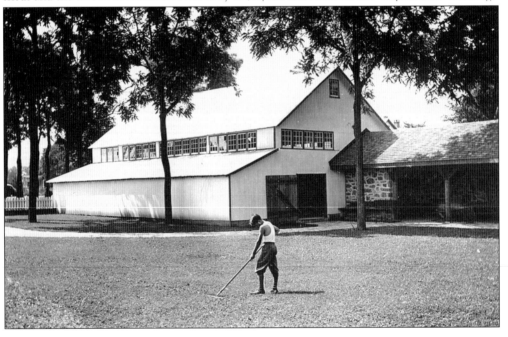

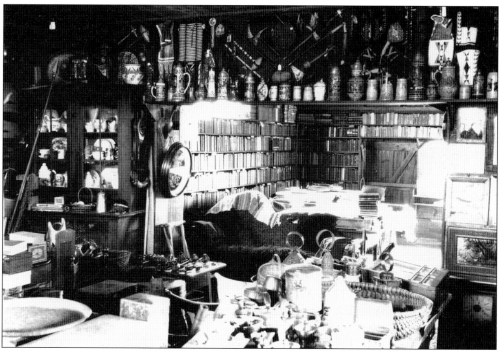

Clutter was the order of the day once the Yellow Barn was constructed and then filled. These views were captioned "Museum in Landis Valley barn 1930?" in Henry K. Landis's album. Of special note are all of the Native American artifacts on display. The plains materials were mostly collected by Henry on his travels and by George on his hunting trips to Colorado. When the Commonwealth of Pennsylvania acquired the site, Carl W. Drepperd, the first director of the newly-renamed Pennsylvania Farm Museum of Landis Valley, arranged to have these materials auctioned off because they were not directly related to Pennsylvania German culture.

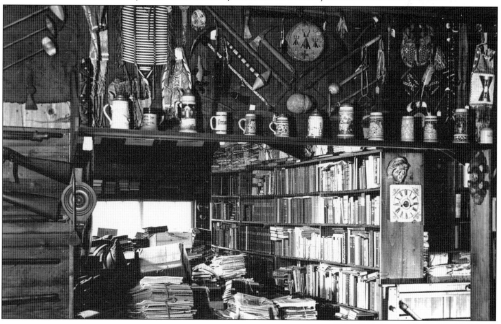

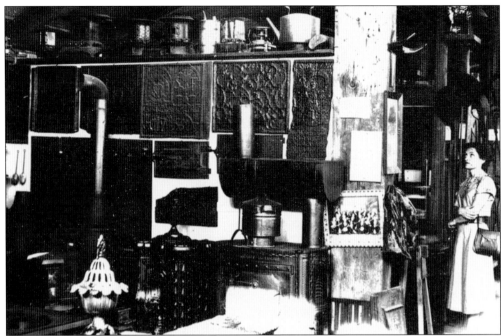

Cleared of its books, in the 1950s, the Yellow Barn was turned into an exhibition building with a number of alcoves devoted to individual crafts or materials. Emulating the exhibition techniques of pioneer collector Henry Mercer Chapman (1856–1930), author of the classic *The Bible in Iron*, the cast iron exhibition emphasized stoves and stove plates. Brass, copper, and tinware made for a gleaming exhibition. The largest copper object in the exhibition is a marvelous whiskey still. At one time, stills were probably more common than mills in Dutch country.

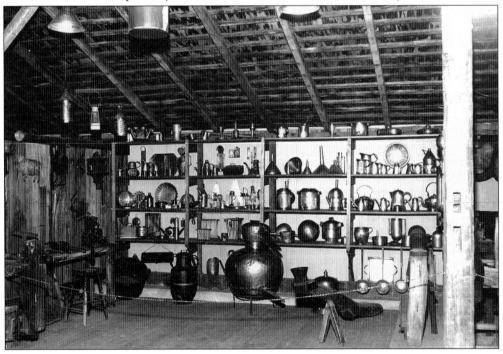

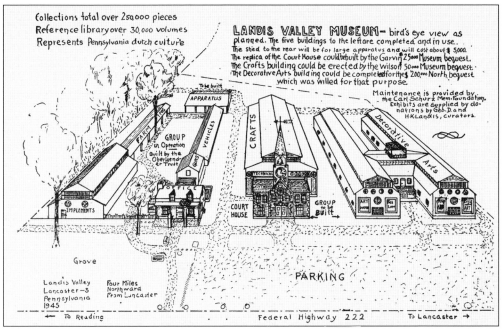

Henry K. Landis's dream for the Landis Valley Museum was strongly influenced by the Henry Ford Museum in Dearborn, Michigan, which is entered through a larger-than-life replica of Independence Hall. The left side of the plan was mostly complete in his lifetime. The right half was never built.

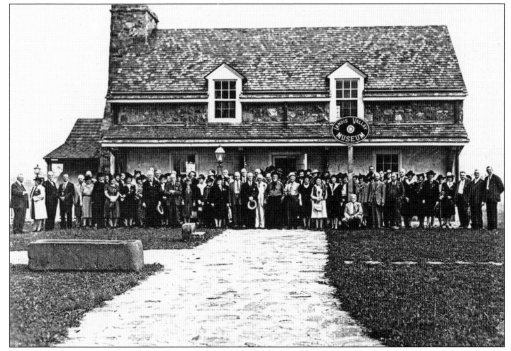

A large group gathers to celebrate the opening of the Stone Tavern at the Landis Valley Museum in 1941. Henry and George Landis stand in the middle.

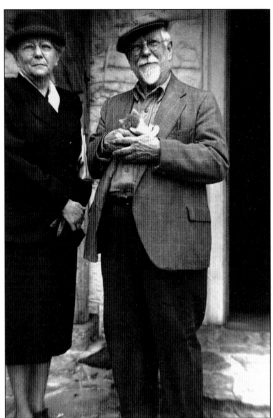

Iva Sard of Jamestown, New York, visits the museum in 1948. Henry cuddles a kitten. Henry relished meeting the public and many photographs were taken of him with visitors.

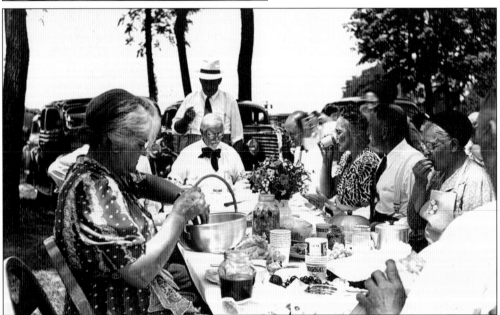

Henry, looking amazingly like Colonel Sanders, the once proprietor and spokesman for Kentucky Fried Chicken, picnics at a Landis family reunion held on the museum grounds in the late 1930s. Note all the Mennonite women wearing prayer coverings.

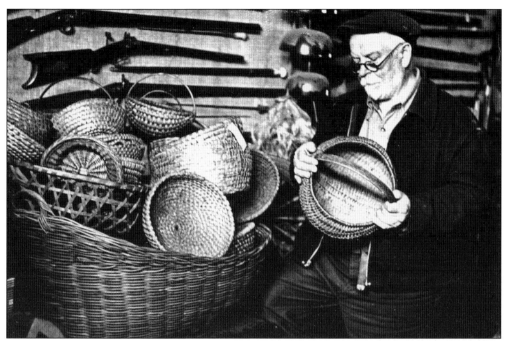

Pictured here are the Landis Valley Museum's curator and some baskets. Henry K. Landis's description follows, "The large basket is a craddle higher at one and in it is a variety of baskets, each designed for some particular use, but a few of the hundreds in the Museum."

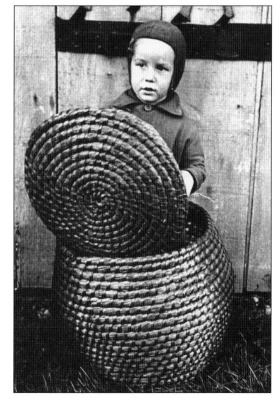

Henry loved cute pictures. The kid enlivened this study of a straw basket. "The example illustrated," Henry wrote, "is the well known dried apple basket. (Schnitz karep) made of oat straw band sewed together with white oak or hickory withes. They were in general use and locally made sometimes by some skilled farm hand."

George Landis liked to keep up with the times, and he enjoyed occasional travel. Here he visits the New York World's Fair in 1940. (The author, who was also at that world's fair, sometimes wonders if he may have been pushed in his stroller past George Diller Landis.) Below, George listens to a radio in the Stone Tavern. The portable was certainly not a regular exhibit in the 1940s.

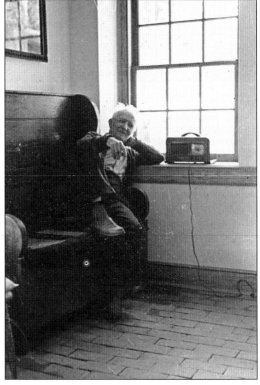

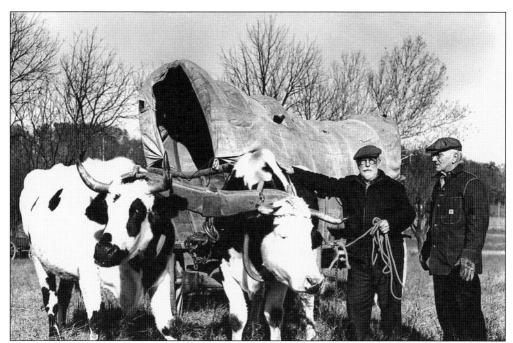

Henry K. and George Landis pose with a team of oxen and a Conestoga wagon in the late 1940s. This is the same team pictured on page 111.

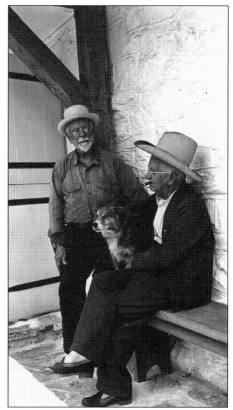

The most familiar image of the Landis brothers is this one of Henry, George, and a dog posed in front of the Stone Tavern. George was usually the more conservative dresser, but here he wears a large hat and quite extraordinary shoes.

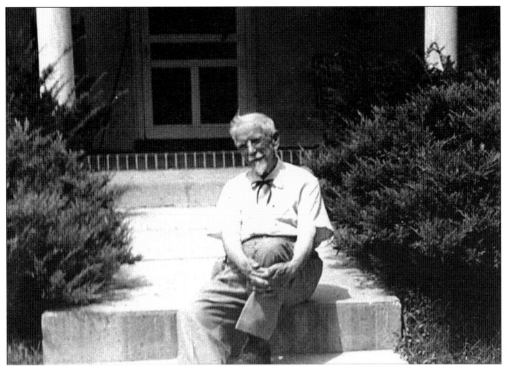

George died in 1954 and his older brother, Henry, with whom he had lived since 1924, soon had to move from the family home. Increasingly frail, he went to live at the Hatfield Nursing Home. In August 1955, on his 90th birthday, he poses on the steps. Below, playing with a peg game that looks amazingly like a television remote, Henry sits in the sun porch at the nursing home. These are the last pictures ever taken of Henry, who died a few months later. He was the last of his line of Landises of Landis Valley, but many Landis kin survive.

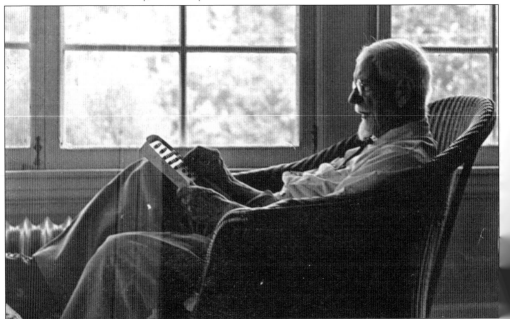

BIBLIOGRAPHY

Boyer, Dennis. *Once Upon a Hex: A Spiritual Ecology of the Pennsylvania Germans.* Oregon, Wisconsin: Badger Books, 2004.

Deitcher, David. *Dear Friends; American Photographs of Men Together, 1840–1918.* New York: Harry N. Abram, 2001.

Earnest, Russell and Corinne. *Flying Leaves and One-Sheets.* New Castle, Delaware: Oak Knoll Books, 2005.

Emsinger, Robert F. *The Pennsylvania Barn: Its Origin, Evolution and Destruction in North America.* Baltimore: The Johns Hopkins University Press, 1992.

Fegley, H. Winslow. *Farming, Always Farming: A Photographic Essay of Rural Pennsylvania German Land and Life….* Birdsboro, Pennsylvania: The Pennsylvania German Society, 1987.

Fletcher, Stevenson Whitcomb. *Pennsylvania Agriculture and Country Life, 1640–1940.* Two volumes. Harrisburg, Pennsylvania: Pennsylvania Historical and Museum Commission, 1950.

Frederick, J. George. *Pennsylvania Dutch Cook Book.* New York: Dover Publications, 1971. Reprint of 1935 edition.

Gladfelter, Charles H. *Pennsylvania Germans: A Brief Account of their Influence on Pennsylvania.* University Park, Pennsylvania: Pennsylvania Historical and Museum Commission, 1990.

Hedrick, Ulysses Prentiss. *A History of Horticulture in America to 1860.* New York: Oxford University Press, 1950.

Heirloom Seed Project. Year 2005 Catalog. Lancaster, Pennsylvania: Landis Valley Museum, 2005.

Johnson, Elizabeth. *Landis Valley Museum.* Harrisburg, Pennsylvania: Stackpole Books, 2000.

Lainhoff, Thomas A. "The Buildings of Lancaster County, 1815." Master's thesis, Pennsylvania State University at Harrisburg, 1981.

Landis, Henry Kinzer. *Canoeing on the Juniata, 1888.* Harrisburg, Pennsylvania: PHMC, 1993

Lasansky, Jeanette. *A Good Start: The Aussteier or Dowry.* Lewisburg, Pennsylvania: Oral Traditions Project of the Union County Historical Society, 1990.

Long, Amos Jr. *The Pennsylvania German Family Farm.* Breinigsville, Pennsylvania: The Pennsylvania German Society, 1972.

Miller, Stephen S. "A Finer Focus of Pleasurable Living: Changes in Manheim Township, Lancaster County, Pennsylvania Agriculture, 1880–1920." Master's thesis, the Pennsylvania State University at Harrisburg, 1994.

Manuscript of the diary of Henry Harrison Landis. Transcribed by Dawn L. Fetler. Landis Valley Museum Archives, Pennsylvania.

Manuscript fragment of the diary of Henry Kinzer Landis. Landis Valley Museum Archives, Pennsylvania.

Null, Hester M. Ed. *The Landis Valley Cookbook: Pennsylvania German Foods and Traditions.* Lancaster, Pennsylvania: Landis Valley Associates, 1999.

Richman, Irwin. *German Architecture in America: Folk House, Your House, Bauhaus.* Atglen: Schiffer Publishing, Limited, 2003.

Richman, Irwin. *Pennsylvania German Arts: More than Hearts, Parrots, and Tulips.* Atglen: Schiffer Publishing, Limited, 2001.

Richman, Irwin. *Pennsylvania German Farms, Gardens and Seeds Landis Valley in Four Centuries.* Atglen: Schiffer Publishing, 2007.

Shoemaker, Alfred A. *Christmas in Pennsylvania: A Folk Cultural Study.* Reprint edition. Harrisburg: Pennsylvania: Stackpole Books, 1999.

Weaver, William Woys. *Sauerkraut Yankees Pennsylvania Dutch Foods & Foodways.* Mechanicsburg, Pennsylvania: Stackpole Books, 2004.

Wenger, Samuel E., compiler. *A Combined Landis/Landes Genealogy Report of the Descendants of Hans Landis and Katharina Schinz.* Akron, Pennsylvania: Samuel E. Wenger, 2005.

Yoder, Don. *Discovering American Folklife: Essays on Folk Culture and the Pennsylvania Dutch.* Mechanicsburg, Pennsylvania: Stackpole Books, 2001.

ACROSS AMERICA, PEOPLE ARE DISCOVERING SOMETHING WONDERFUL. *THEIR HERITAGE.*

Arcadia Publishing is the leading local history publisher in the United States. With more than 3,000 titles in print and hundreds of new titles released every year, Arcadia has extensive specialized experience chronicling the history of communities and celebrating America's hidden stories, bringing to life the people, places, and events from the past. To discover the history of other communities across the nation, please visit:

www.arcadiapublishing.com

Customized search tools allow you to find regional history books about the town where you grew up, the cities where your friends and family live, the town where your parents met, or even that retirement spot you've been dreaming about.